Photographing the
Patterns of Nature

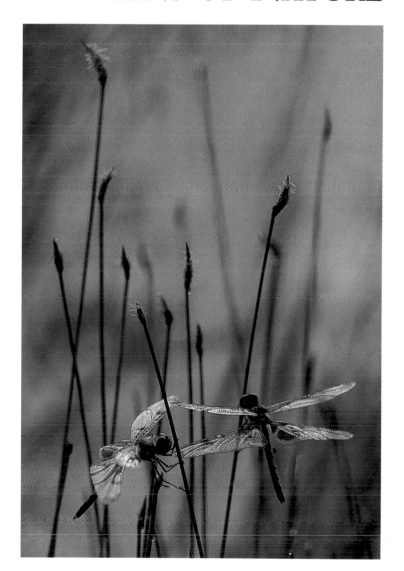

Photographing the Patterns of Nature

Revised and Updated

Gary Braasch

Amphoto Books

An imprint of Watson-Guptill Publications/New York

CONTENTS

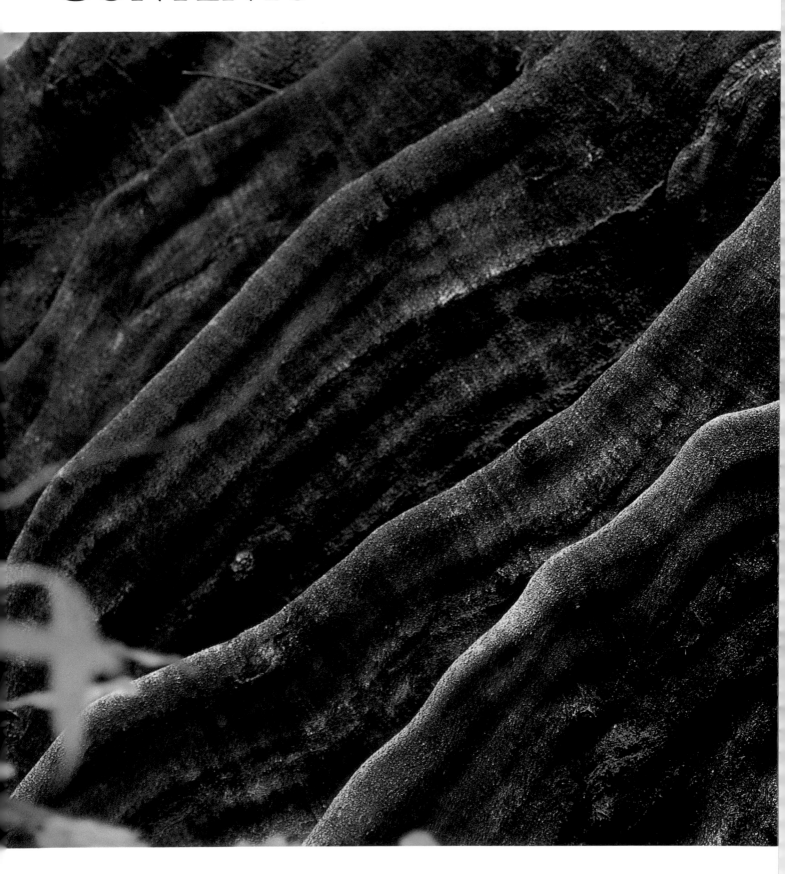

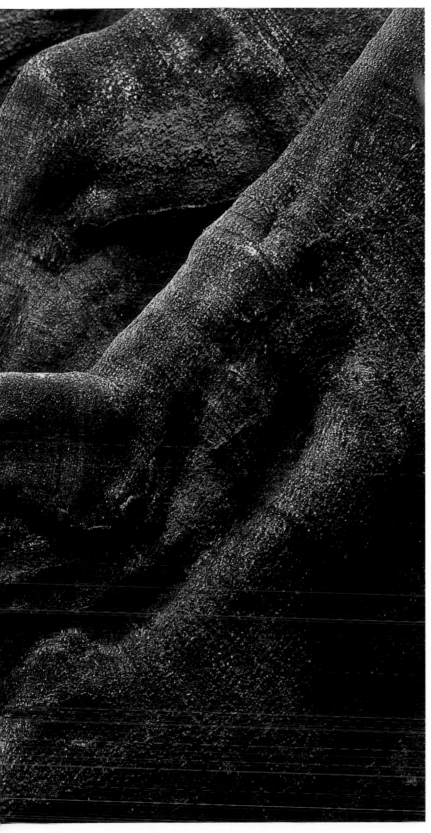

INTRODUCTION

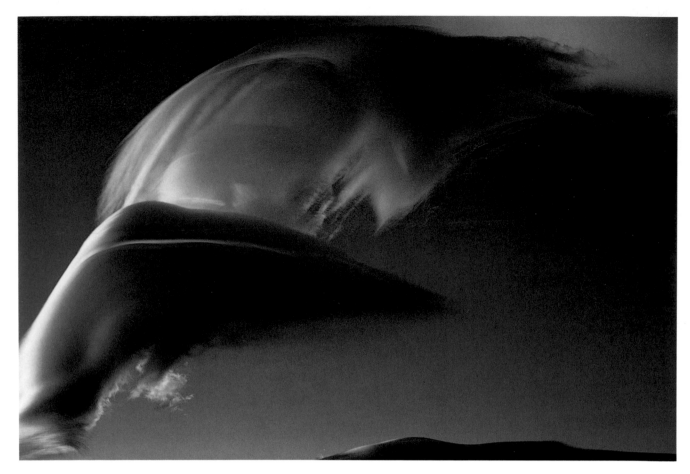

I'd lived in the Northwest only a year when Chip Greening, my fellow mountaineering friend, and I attempted to climb Mount Adams. This extinct volcano in southwest Washington is more remote than other Cascade peaks, but the long backpack journey to it was a joy: clear skies, gardens of wildflowers, and not a hint of bad weather to the west. Although Mount Adams is no great alpine challenge, its 12,000-foot height and attendant glaciers and lava cliffs require full mountaineering skills. Chip and I slept only a few hours, and before daybreak were drawing on cold boots and preparing our rope harnesses by flashlight. I didn't own much camera gear then, but I'd learned to take it everywhere, and so my Nikkormat FT camera, Vivitar 28mm lens, and a supply of Kodachrome were around my waist in a fannypack.

Chip and I weren't even close to the summit when, shortly after dawn, Mount Adams began making its own weather; the wind rose very rapidly, and sudden gusts laden with stinging ice particles and cinders began pounding us. Forced to take shelter behind some large boulders, I looked up to see a fantastic sight: above us a dark cloudcap had settled over the summit. The raging wind was actually blowing the cloudcap off the mountain, while another continuously formed behind it in a great white fabric of cloud, arcing up and away from the main lenticular formation. The cloudcap caught the gleaming sunlight in its billows and waves and quickly dissipated in the drier air beyond.

I watched, spellbound, then instinctively put my camera to my eye, composed a section of the huge cloud formation with my 28mm lens, pressed the shutter, rewound, adjusted the exposure, shot again, rewound. . . . out of film! By the time I could reload in the shelter of the boulder, the cloud had evaporated. The moment was over. Chip and I

looked at each other, assessed the ferocious wind and ominous clouds over the summit, and decided to descend.

Of all the slides I shot that day on Mount Adams, I've kept only one—because only one ever mattered. That perfect, magnificent, magical cloud exposure—the *last* one on the roll—has been crucial to my career and symbolic in my life. It helped garner professional interest in my work, and it encouraged me in my photography before I fully understood what it would take to be a freelance nature photographer. It was published almost immediately and often, notably in the legendary *Oregon Rainbow* magazine and *Popular Photography*. This singular image has dazzled many viewers, and one was even inspired to give it the name it has since carried, "Dolphin Clouds." With its arching beauty and upward, hopeful symbolism, this photograph has taught me the power of shape, light, and design.

My love of nature and my love of photography go hand in hand. Through them I connect with the world, its people, and the elemental forces of life. As a nature photographer I find pleasure and peace in a quiet moment anywhere; I become, in some small, laughing way, a child again. I wouldn't be a photographer if I didn't really enjoy studying nature and looking at pictures. For me, photography is magic. Even when depicting the everyday, photographs can reveal unexpected and mysterious meanings. After a few moments of looking at a good photograph, you see something deeper about the subject and understand it a little better. My favorite subjects for exploring these deeper meanings are the patterns of nature.

Countless patterns exist in the universe, yet no student of nature can ever hope to know or photograph more than a few of them. I keep to the terrestrial realms. The incredible patterns of undersea life aren't a large part of my work, and I haven't ventured much into the world of microphotography—where the outer limits of electron microscopes now image the atom itself. Concentrating on the designs in nature opens up a wonderful new appreciation of the world, which can be the impetus for a life-long career in photography. It brings nature and the miracle of ongoing creation in the world to the tips of your fingers.

This book's approach to outdoor photography emphasizes understanding and seeing the grand designs of nature, as well as using them to make better pictures. My purpose is to help you to see the world with a fresh vision through the selective perspective of your camera. The patterns of nature are all around you, but as a photographer you must become sensitive to their presence. I believe that stronger, more interesting photographs are made by people whose vision encompasses a knowledge of the patterns existing in the natural world along with an understanding of the symbolic meanings assigned to them. Such photographs reveal the hidden poetry of the world, a poetry that stays hidden only when you don't take the time to look deeply enough.

Patterns can be discerned in the growth of plants and animals and in the ways they interact with their world. Patterns exist in the change of seasons, the surfaces of the earth, and the expanse of the stars. Look for patterns in the motion of the world: trees and grasses in the wind, the ebb and flow of water on the shore, the flight of birds, and running animals. Even if your home is a large city or your life consists of constant travel to many cities, the immense beauty of the world is always at hand. You can enjoy the play of leaves on a tree-lined street or the delicate geometry of flowers in a single window box. Often, only a few steps from the swirling humanity of an airport terminal is a park or stretch of land just waiting to be explored. Some natural jewel of creation is always within your camera's grasp.

One of the keys to photographing the patterns of nature is the idea that the whole is manifest in the part. For example, the minute detail of a shell can evoke the vast beach it was found on, as well as the growth pattern of all shells. This spiral growth—turning outward and inward at the same time—might stir specific personal memories, but it is also a symbol of everyone's inner journey. It brings to mind the image of a child listening to the ocean's roar and all the curiosity and wonder that magic gesture represents.

Small details in a scene are often what lead both your eye and your mind to an

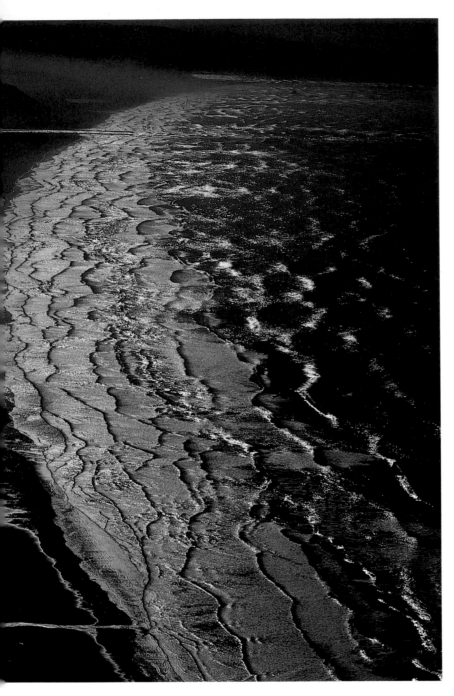

nature's patterns might be more like anecdotes, but the allusion to storytelling is appropriate because of the way in which your eye is lead inside an image, from element to element. Being able to narrate these visual stories doesn't require a degree in botany, geology, or art. Training your camera on the world leads naturally to more careful observation; the more you photograph, the more you'll learn.

The wondrous variety of life on earth evolves from a few organic shapes and motions that are always visible, if not fully understood. Yet, these designs and colors share a common language with your thought processes. The idea is to learn about these natural patterns and use them to make more interesting, more dynamic photographs. Many of the world's most celebrated artists, writers, and photographers are known for their interpretations of nature's designs. An important and ongoing part of my education in patterns has been to look at numerous pictures and read as much as possible in nature books, both fiction and nonfiction. I urge you to do the same, keeping in mind that these works, like my photographs in this book, are merely suggestions of the richness of perception available through your own eyes.

This book will show you how to photograph growth, flow, and change in the natural world by improving your composition, focusing, and lens choice. You'll learn where to look for the various individual patterns of nature—the lines, curves, forms, and textures that are created by growth, flow, and change—and how best to photograph them. As the book illustrates, you can combine these patterns to make ever more complex and meaningful images. I'll also share my personal responses to the sometimes overwhelming complexity of the natural world, which, I hope, will help you determine the strongest subjects, compositions, and lighting effects for your images. Finally, I'll discuss the business world of nature photography, its contacts and contracts, to help you plan a possible career, prepare you for assignments, and direct you to opportunities for marketing your pictures.

There is perhaps less emphasis here on the strictly technical part of nature photography.

Curve upon curve of waves advance upon Neahkanie Beach, Oregon, as the low winter sun provides backlighting. Shooting from a nearby mountaintop, I made this picture with a 300mm lens.

understanding of the big picture. The way a cloud's shadow falls across the hills, the shape of a stream flowing into the valley, or the patterns etched by wind into the side of a mountain can make you think about the evolution of air, water, and land—the elemental patterns of the earth. What these images have in common is a quality of storytelling. Like Granddad on the front porch, starting another one of his yarns, these pictures have a way of involving you even before you notice what is happening. The simplest photographs of

In my view, today's camera equipment makes it increasingly possible to make technically great images without knowing precisely how the camera does it. For me, the emotional call of a scene I'm driven to photograph has been the motivation to sharpen my technical skills, not the other way around. I've also learned how to be patient, how to concentrate deeply on small details and events for long periods of time, and how to be mindful of timing in the natural world. No book taught me these skills before I first ventured out with a camera, but I can help you with some of them now so that you'll be better prepared.

Nature photography has been a very dynamic field in the years since this book was first published. Improvements in films and cameras make possible more beautiful and technically difficult images. Innovations in electronic imaging and communication, particularly the World Wide Web, have changed the way photographs are made, stored, displayed, and delivered. There has been consolidation—some would say upheaval—in the markets for photography. The North American Nature Photography Association was founded, and among its early roles was leadership in newly visible issues of ethics in how and where photographs are made and published. Both artistic and environmental photography have reached new levels of beauty, style, and meaning. It is also true that nature photographs are more and more needed as witness and symbol of a wild earth that is increasingly damaged by human civilization.

This book is about the everyday, visible motions and designs of the earth, and is a personal selection of images, presented with the hope they'll lead and inspire others not only to see more and learn more, but also to care more for this fragile planet that we call home.

In nature photography you are never far from discovering new subjects and patterns that can become your focus for celebrating and protecting the earth. The job of informed and creative photographers is to use these patterns to make a stronger connection between the natural world and people who are increasingly isolated from it. There is little doubt that much of the earth is under assault by the worldwide industrial pursuit of raw materials, agribusiness, housing and commercial developments, expanded road networks, and consumerism. These are the major causes of global extinctions of species. Population pressures compounded by a skewed economic system speed the diminishment of natural, irreplaceable support systems that keep us all alive.

Environmental Photography: Your Images at Work for Nature

I wish all nature photographs would be used, whether to friends in a living room or to 10 million people via *National Geographic,* to enlighten people and keep them from plundering the entire planet. Unfortunately, nature pictures are used just as often to sell unnecessary and unhealthy products and provide green smokescreens for polluters. The power of nature, conveyed by the photograph and used by advertisers, environmentalists, artists, and educators alike, is very great. That is why these images flood the culture, and for many they are the only contact with the natural diversity of the planet. How nature images are used *does* matter. I hope you'll be inspired by the patterns of nature, learn about them, photograph them from the heart, and use them honestly. Let them reach deep into your soul and bring forth great energies of love and care for our earth.

Part One

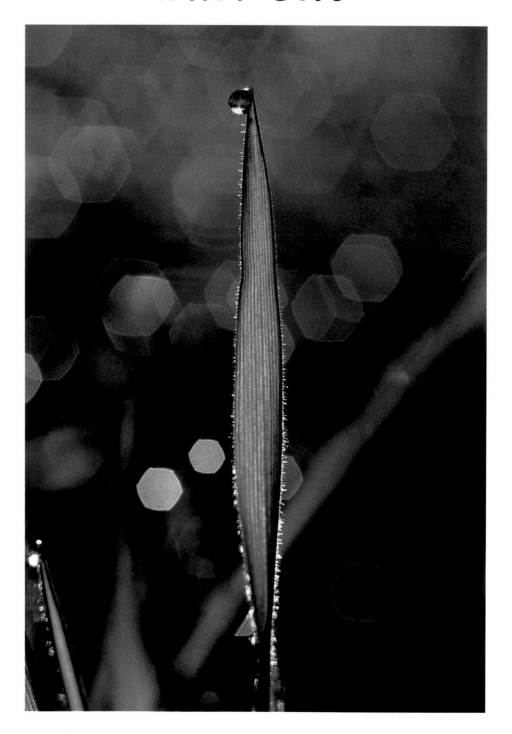

RECOGNIZING
PATTERNS

I WAS SEARCHING for the perfect drop of dew, and nothing was going to stand in my way. I might as well have been searching for the Hope Diamond! The task, to say the least, was arduous—you can't usually see, much less photograph, dew without a lot of stooping and crawling. In fact, I've spent entire days slithering on my stomach across damp meadows, doing what photographers Ernest Braun and David Cavagnaro have termed "wet-belly photography," on the trail of these tiny, scintillating drops of water.

On this particular day I'd been scrutinizing dewdrops on fresh grass shoots in spring meadows, parks, and newly seeded suburban yards when I discovered this gem—in a cemetery. Creating photographs like this isn't as easy as it might look, especially after several cold, pre-dawn hours of scouting have stiffened your bones and soaked your pants right through your raingear. But this was an exceptional find. An absolutely upright, unblemished blade of grass, a spherical lens of water at its tip projecting the moment of sunrise, and in the background other drops of water shone with beautifully refracted rainbow hues. I had to work fast since the moving sun could cast a shadow across the grass and change the wonderful angle of light, and I had to be careful not to disturb the delicately balanced jewel of water. While thinking about how best to capture the blade of grass on film, I decided that too much depth of field would diminish the softness of the background, but with too little, most of the blade would be out of focus. Working with my old Micro-Nikkor 55mm F3.5 lens and its extension tube for a 1:1 closeup at f/5.6, I struggled to keep the camera back parallel with the grass. The left end of my Nikkormat camera body was held against the ground for support, my face was pressed into the grass behind it, and my right arm was cocked up to reach the shutter release. This wasn't the first or the last time I've heeded the advice of the old cliché: "Shoulder to the wheel, nose to the grindstone, ear to the ground. . . ." It made a wonderful picture. Although not as magically abstract as "Dolphin Clouds" (see page 8), this image is even more symbolic of concepts like spring, growth, purity, sunlight, and the importance of plants. Like the clouds photograph, this shot has enjoyed wide publication and helped introduce my work to thousands of designers and editors. More important, this photograph set the standard for sharp, well-composed, meaningful nature images that has driven me ever since.

Out there in that wet grass I was searching with a purpose, looking for a specific design in nature: the upward thrust of a growing plant and the perfection of a crystal orb of water. During my foray, I passed many other patterns—spider webs, dried seedpods, trees against the dawn sky—some of which I also photographed. I'd begun to see and learn how common these designs were, yet also how visually intriguing and revealing about the workings of nature. Learning this sharpened my powers of observation. I became curious to know more and studied books and other nature photographs. I was, in effect, training myself to recognize patterns.

THE FUNDAMENTAL SHAPES

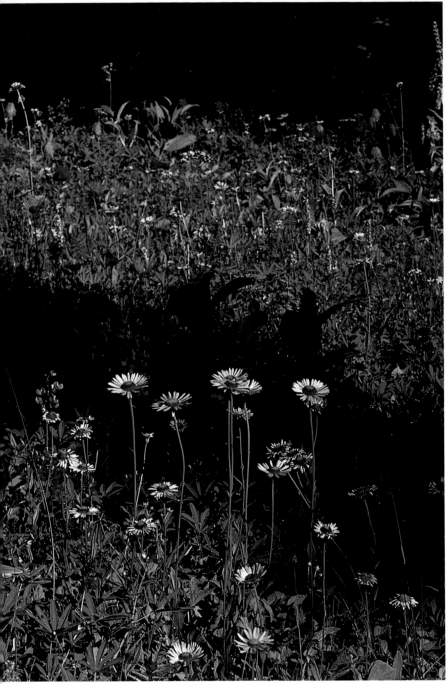

A patch of pink daisies on Heather Ridge in British Columbia's Manning Provincial Park stands out against a dark strip of shadow cast by a fir tree. A one-stop underexposure on Fujichrome 50 deepened both their color and the shadows, strengthening the picture's design.

A field, although very beautiful as a whole, is composed of many individual grasses, tiny wildflowers, last year's dry seedpods, and myriad insects and small animals. Upon closer inspection, it becomes clear that each of these is part of countless patterns. The field itself comprises patterns of wet and dry ground, rising and falling terrain, and the shifting light and shadows of sun and clouds. When looking at a lone tree, no matter how beautiful its silhouette, take time to notice the texture of its trunk, how the branches spread from its center, and the way some of them twist or thicken in response to the tree's inner chemistry and surrounding environment. In this continuing odyssey to the heart of nature's designs, you'll discover that there are patterns within patterns—and all of them together mirror the whole pattern of the world. For example, the branching of trees resembles the branching of arteries and rivers, the fiddleheads of ferns spiral like shells and galaxies, and the designs of cracked mud mimic the spots on a giraffe.

In Pete Stevens's excellent book *Patterns in Nature*, he writes, " . . . the immense variety that nature creates emerges from the working and reworking of only a few formal themes. Those limitations on nature bring harmony and beauty to the natural world." These few visual themes—lines, circles, spirals, triangles—are the master patterns from which all others evolve. They recur over and over in the world. I watch for them in everything I photograph because they help clarify the multitude of visual possibilities and enable me to see more. They are the raw materials with which to construct photographs of natural patterns, growth, and form. Although they seldom occur alone in nature, I've illustrated them here separately to emphasize their individual characteristics.

There is a crucial difference between what you experience when you photograph these basic forms and what viewers perceive when they look at the pictures. You experience the scene with all your senses alive: you see *around* the camera with peripheral vision,

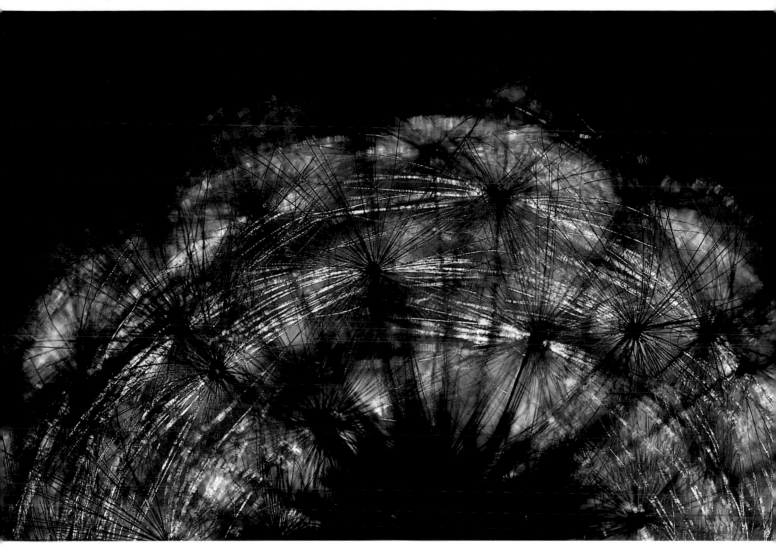

hear the ambient sounds, smell the odors, feel the air on your face, and perhaps even taste the rain or your own perspiration. The photograph is part of a day you lived, and you can never think of it without calling up at least a few memories of the work and experience. However, when the shot is finally developed and you show it to friends or editors, they experience only the shapes and colors of the image, framed in a silent, self-contained, two-dimensional rectangle. They have no way of perceiving the emotional or physical experience you had while capturing the image. Although you might get to explain the picture, their first impression is that of the image alone. So it has to convey all the excitement, discovery, and real mean-

ing of the scene as you experienced it. And in the professional world, editors don't care how much trouble or excitement you had making the shot; they care only that it works on the page.

How do you make photographs that do this? Learning to recognize the elemental patterns of nature is the first step. Sensing what emotional messages an image projects is the second. The next step involves creatively using the tools of technique, such as aperture, lens choice, and exposure, to interpret these messages clearly onto film. Take the risk. Dare to make photographs that are alive with emotion and eloquently express not only your skill but your feelings as well.

Extreme closeups reveal worlds of pattern invisible to the naked eye, such as the colors that are diffracting in this dandelion pappus.

Lines

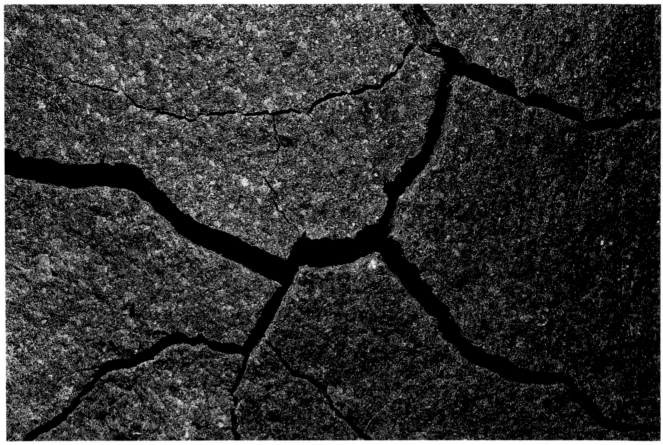

The line is the most elemental tool for making a picture. Whether you draw one in the sand with your finger or program one on a computer, a lines defines and describes edges and boundaries of shapes: the boundaries between air, land, and water; the narrow profiles of stems, trunks, cracks, and surface markings; the edges of cliffs and meadows. Lines lead your eye as it explores an image. You can sense this happening as you simply look at photographs. Your eyes become energized by the process of seeing lines and shapes. Some patterns of lines are chaotic and seemingly random, like scattered straw. Maybe that is why finding a horizontal line in a scene is so comforting.

When your eye finds a horizontal line, your mind reacts very strongly. The horizon line is a crucial part of your everyday orientation. The line between the earth and the sky is the major division of the world. It is restful and psychologically soothing. It makes you feel grounded, as well as secure that you have your basic coordinates. In the

visual arts, where the "world" of each picture is contained within the frame, viewers search for that important horizontal line to orient them. For example, if cartoonists want you to read solid ground under a character, they need only draw a quick line across the frame for you to immediately understand.

In photography, too, a horizontal line orients viewers and gives a photograph a sense of place. Whether the picture is an abstract image made through a microscope or an 8 x 10-inch, large-format depiction of Yosemite, the position of the main horizontal line is crucial. If it is placed at the top of the frame, the foreground will gain importance in the viewers' minds; if it is close to the bottom, it will emphasize whatever subject is higher in the frame. A straight line also leads your eye from one side of a picture to the other and highlights the objects that fall along the line. Leaving out a horizontal line can disorient viewers the way fog can disorient travelers. They don't have anything to take hold of or any direction to look in.

Jagged lines are riveting metaphors for violent change. I opted for bright sunlight and a 55mm lens to shoot these 1-inch-wide cracks in fresh lava rock from Mount St. Helens.

A horizontal line can be especially important in closeup and abstract images, even though it is unlikely to be the actual horizon but rather an edge or boundary between objects. Nonetheless, it gives the image a landscape that is restful, comfortable, and familiar. Keep in mind, though, that as with any graphic element, an overabundance of perfect horizontal lines can make pictures too repetitive and, ultimately, boring.

The strength and directness of lines gain added meaning when they run at angles other than horizontal. Few things in nature are straight, but those that are have a purpose. Often these evolve as weapons of offense and defense, like teeth, spines, and thorns; they occur as dominant forms in the landscape, such as thrusting tree trunks; and they are seen in stiff, spiky plants that act as

natural barriers. These contrasting lines also take the form of cracks of lightning and the serrated ridges of mountains that have been ripped into being by an earthquake or frost.

Vertical lines represent the other major aspect of daily orientation: direction. On maps a vertical line with an arrow indicates the all-important compass point: north. In pictures vertical lines connote action, in contrast to the restful effect of horizontal lines. Verticals convey a sense of strength, motion, and upward growth; objects that stand vertically, like trees and humans, defy gravity's pull back down to the horizontal.

An even greater sense of action is conveyed by lines that slant, suggesting up- and downhill movement, as well as leaning forward to increase speed. In nature you find slanted lines in tree trunks blown by storms,

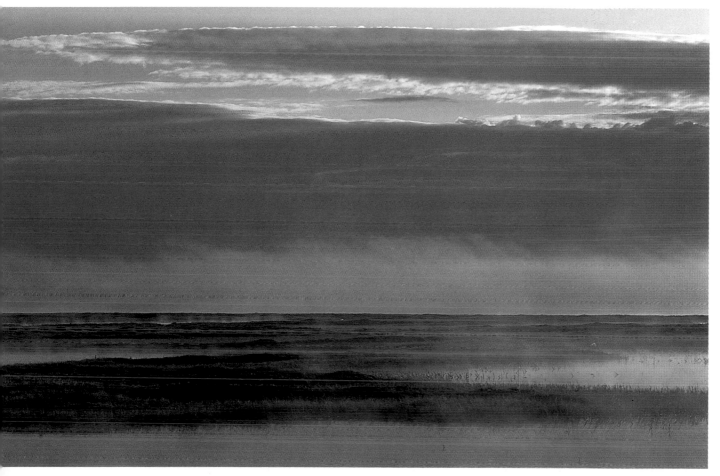

A telephoto lens emphasized the subtle topography of the tundra as the low midnight sun illuminated the mist rising from polygon lakes along the Arctic Ocean. Bands of clouds complete this composition of horizontal lines.

An insect, feeding upon a palm leaf while still folded in the bud, created an opposing pattern of diagonal lines for my composition. I made this shot with a 55mm lens on Fujichrome 50 in a sunlit tropical forest.

Just after Hurricane Andrew cut a horrifying swath across southern Florida, I photographed Everglades National Park. These broken, denuded pine trunks provided a witness to the storm in strong vertical and diagonal lines silhouetted against the sunset.

the angle of driving rain, the precipitous slope, and the wing of a descending hawk. Viewers can become uncomfortable, and even feel a sense of danger, when presented with slanted lines that form jagged edges and sharp points because these lines are associated with painful objects, such as knives and spears.

Straight lines other than the ever-present horizon sometimes aren't readily discernible. Learn to recognize them in isolated portions of a scene, such as a telephoto view of a curving butte's serrated top rocks or a closeup of the rigid lower stems of grasses. Flat, open expanses, such as lakes and fields, often look like lines when seen from a distance at a low angle, and they can be used in pictures to echo the horizon. Falling rain or snow brilliantly illuminated against a darker background can become a pattern of lines on film if you use a slow shutter speed between 1/8 sec. and 1 sec. (snow falls more slowly than rain, of course). Try focusing on the precipitation itself or on an object in the midst of it.

The way lines are patterned in a photograph also depends on how you focus them. The straightness of a line is reinforced when it is in focus. Lines that go in and out of focus along their length create a three-dimensional effect of depth. Shallow focus can also effectively emphasize a very sharp, straight object by making it stand out against the out-of-focus background.

Most lines in nature have an obvious "correct" orientation in a photograph. For example, rain seldom falls sideways, and grass doesn't grow down. It seems like stating the obvious, but many great landscape pictures have been diminished by the photographer's inattention to capturing the horizon. This is especially true of very wide-angle images in which the horizontals are optically curved by the angle of the lens. If you have a camera with interchangeable viewfinder screens, use a grid screen with horizontal and vertical lines etched on it to help you find, and keep, lines perfectly horizontal or vertical. Try photographing lines in a variety of ways—use different focal lengths, and play with composition, framing, depth of field, and angle of view. You can interpret a single line many ways.

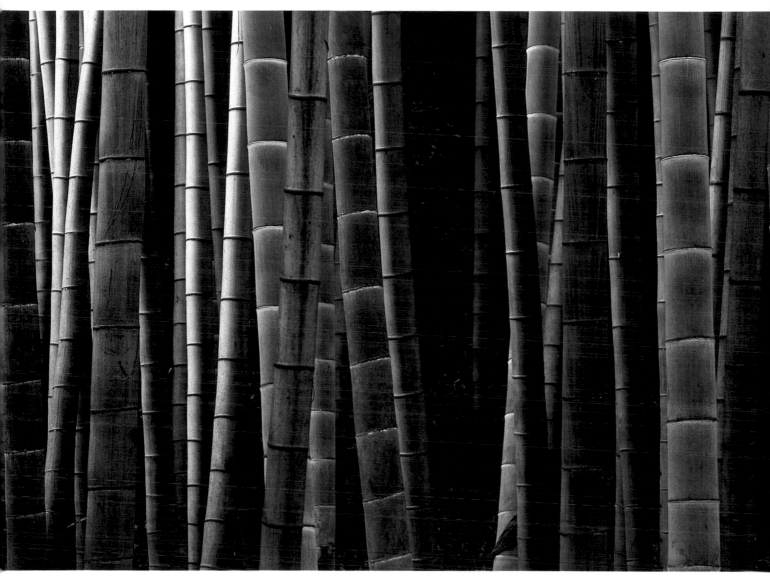

In the Saihoji Garden in Kyoto, the mesmerizing vertical effect of these overlapping bam-boo canes caught my eye. My 105mm lens provided enough foreshortening to enhance the illusion of their impenetrability

Curves

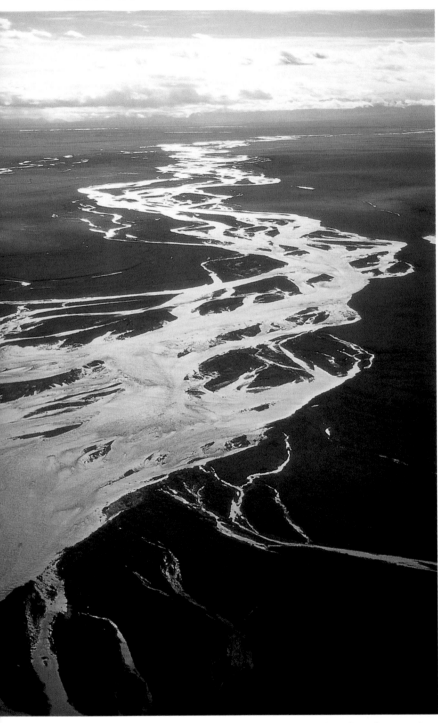

The Sadlerochit River in the Arctic National Wildlife Refuge flows to the Arctic Ocean carrying a heavy sediment load, which causes the meandering channel to separate and reform. I shot into the light from a low aircraft to highlight the multiple curves of this braided river.

A curving line, which represents motion and growth, can be seen in the bending and folding of surfaces and layers, the arc of birds in flight, and the energy in the atmosphere. Few lines in nature run straight for very long, and when they bend, they all conform to the same laws of physics: continuous repetitions of simple forms and complex sinuous combinations. An accumulation of curves creates a visual symphony. Music is an apt metaphor for curves because both sound and light are carried on curved waves that your senses are designed to interpret. You can derive much satisfaction from the sound and sight of water in fluid motion, and everyone responds to the curves found in landscapes, plants, and weather occurrences.

In both liquids and the atmosphere, waves are created by the slightest disturbance—for example, a breeze on the surface of a lake, a pebble in a quiet stream, and even the different speeds of wind in the same cloudy sky. Such curves are endlessly fascinating, but the best photographs are often those that focus on symmetrical or highly reflective waveforms, especially those reflecting trees or clouds coiling across the surface of water in ever-changing elliptical abstractions of contrasting color. These images require a fast shutter speed and fast focusing reflexes. Many cloud formations don't move as quickly, but they still change their shape dramatically over the span of minutes, as do their pink and golden colors at dawn and sunset. Patterns of fluid curves and waveforms seldom remain in place for long because wind speed, flow, and atmospheric conditions change continually. Waves contract, expand, and swirl over themselves in continual eddies of turbulence.

Rivers and streams flow across gentle landscapes in great repeating arcs as currents within the flow move from side to side. The Greeks were fascinated by this natural pattern of motion: the word "meander" comes from *maiandros*, the Greek word for winding, after the river now called the Menderes in western Turkey. The motion of these S-shaped curves is a result of mathematical

and hydrodynamic laws. From tiny rivulets in a meadow to the great Amazon River, all waters obey the same laws, and their meanders follow the same shape. The process of downhill erosion moves the entire meander system downward into valleys. A river filmed in time-lapse photography would look like a giant snake moving across the landscape. If you could film a time-lapse sequence of a million years, you would see clearly how this motion carves out the landscape. The Grand Canyon is a triumphant example of this natural power of erosion. In real time these forces can be seen at work shifting sand dunes and snowdrifts across the earth's surface.

Photographing large, curved shapes and waveforms profits from a good angle of view for composition, as well as from sidelight to accentuate the edges of the shapes and the declivities that they form when bunched together. Cumulus clouds perform magic for patient photographers any time of day by casting shadows across some rolling hills and leaving others accentuated in sunlight. Watch the light, too. Brilliant backlighting can ignite a river with color, while underexposure will turn the bends of a river shot at sunset into fiery arcs set in a dark landscape.

Curves are also created by the growth of living things. The twisting and curling of plants and surfaces in nature are caused by

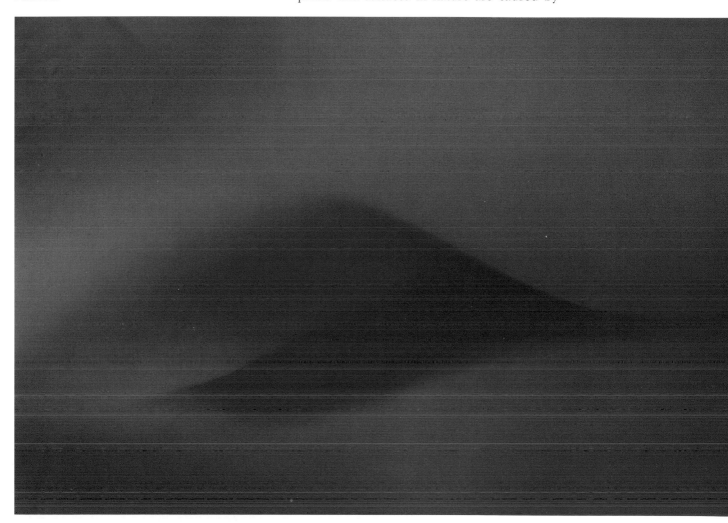

The body-like curves of a rose's interior petals were held in shallow focus with a 55mm macro lens on a 1-inch extension tube. Overcast lighting enhanced and deepened the various color values.

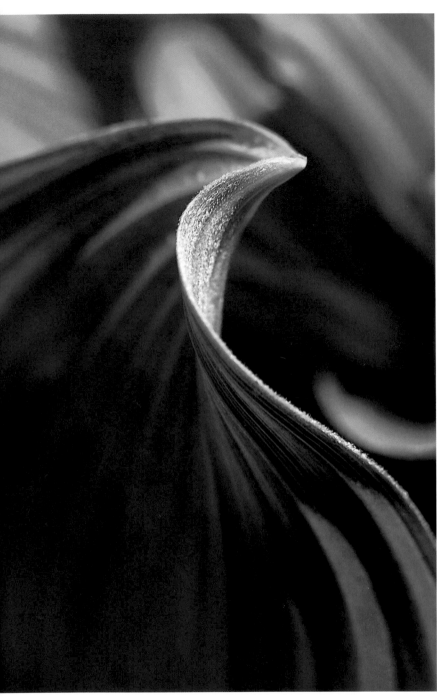

different growth rates or by uneven rates of contraction and expansion within the objects. Longer surfaces wrap around shorter surfaces. This can be seen in peeling bark and drying mud, curving stems and leaves, and spiraling shells and horns. The curving motions of animals are created by the same principle. The muscles of a snake or a flamingo's neck contract and curve with their natural movement.

Focus is important when you photograph the shape and motion of curves, especially when there is much detail that distracts the eye from the emphasis on the curve. Focus very carefully when curves are in motion, such as in clouds or water. Try different apertures and use your camera's depth-of-field preview button to determine the best aperture for accentuating the curve without showing too much background clutter. In closeups it is rare that the entire curve can be in focus because of the shallow depth of field involved. You must make a compositional choice about where to place the shape for the best graphic effect. I've found that framing it in the foreground is best because that is where viewers tend to look first. As with many techniques for photographing the patterns in nature, taking extra time—and using a lot of film to experiment with focus, lighting, and composition—pays off in finding new ideas about what makes your photographs personal and interesting. Only by taking many photographs will you get a sense of what does and doesn't work.

A moment of glancing light illuminated the edge of this false hellebore leaf, enabling me to capture an elegant S-curve with a 55mm lens.

I barely kept this great egret in the frame of my 500mm lens as it took off right in front of my blind in the Florida Everglades. The bird's beautiful neck and wing curves are echoed in the water, and the slight softness of the image emphasizes the egret's motion.

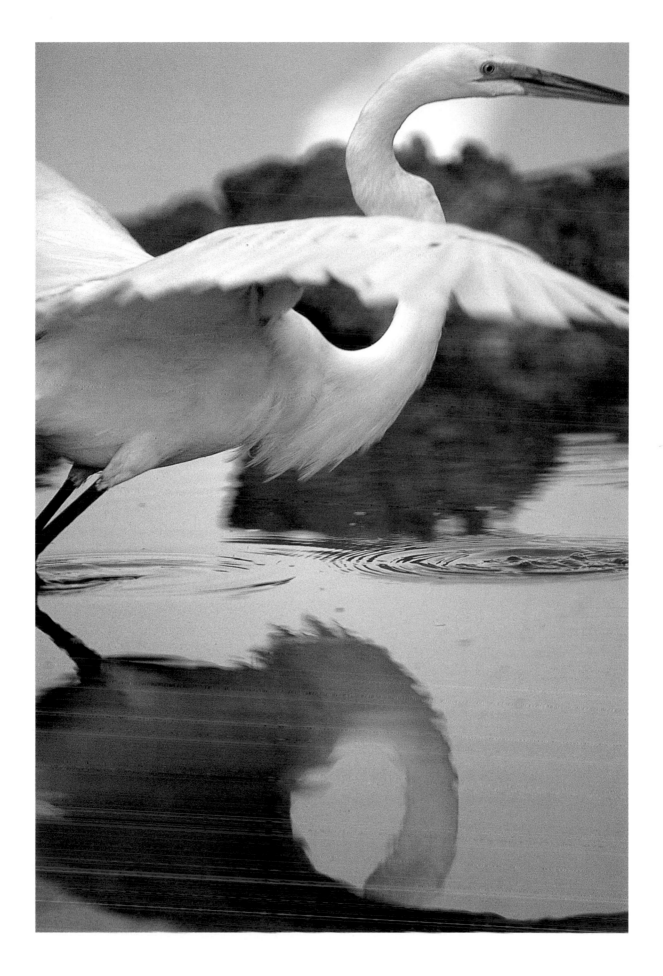

Spirals

Spirals depict the universal pattern of flowing forces gracefully unfolding and interacting: the inward-turning nautilus, a blooming rose, or a ram's horn. The grandest spirals are formed in space as the radiating thrust of stars and energy surging from the center of a galaxy is turned by its rotation. A more commonplace but similar pattern occurs in your bathroom tub when water rushing into the drain is turned into a vortex by the force of gravity and the earth's spin. Spirals result whenever one fluid force overtakes or pushes against another, whether it is cream flowing into hot coffee, or moist, warm air moving against cooler air and creating the planetary storm patterns visible from space. In the plant and animal worlds, natural clocks time the spirals produced by growth. Many spirals are created as one side of either stems and tendrils continually grows faster than the other does. The spiral shape uses an economy of space; a fern frond, for example, develops in a much smaller area than it could

if it were formed in a straight line. Spiral growth enables more leaves and seeds to develop in or on a given surface than other possible forms of growth, as evidenced in the familiar patterns of sunflower florets and conifer cones. Orb-weaving spiders expertly utilized the efficiency and strength of the spiral form in their radial webs.

The incredible, creative presence of spirals hasn't been lost on inventive and curious minds. Spirals have been painted and carved into stone for thousands of years as symbols for the journey of life, death, and rebirth, and for the inner secrets of the soul. Visualize the entwined spirals of the Asian concept of yin and yang, which symbolizes perfect harmony. And with their mesmerizing effects of motion and depth, spirals are one of the most common motifs in primitive drawings. They retain their power for us today in the form of DNA's double helix, the spiral ribbons of the basic genetic structure of life.

Photographing the center of a rose almost at life-size with a 55mm macro lens threw the outer petals out of focus. Against them, the sharply focused sworl brings to mind the boundless power of growth.

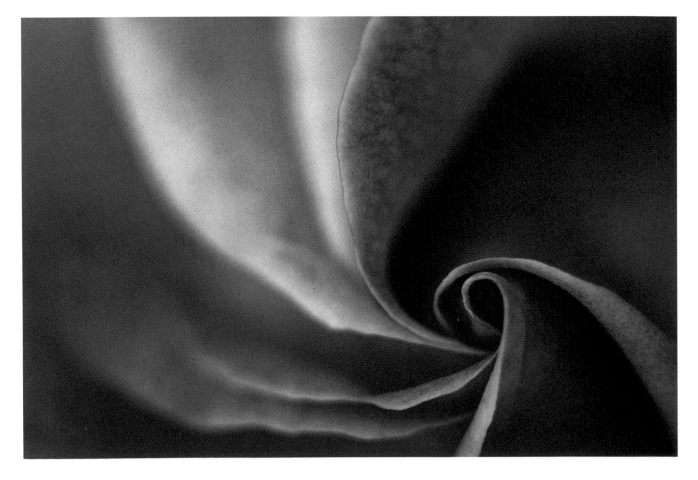

Capturing the spiral's powerful characteristics on film can be difficult, though, especially when the subject to be photographed is as tiny as an unrolling fiddlehead fern or spirals in three dimensions, like a winding whelk shell. Although shallow focus is an asset when photographing curves, using it to shoot a three-dimensional spiral detracts from the inherent geometry of infinite depth. Spirals have the illusion of eternal motion; they end only to begin again. You must photograph a flat spiral, like a web or flower head, with your camera parallel with the subject, no matter what physical contortions this position might require you to perform. A shell, horn, or thick frond might call for the use of a tripod to ensure sharpness due to the small apertures and long exposures needed to keep the subject in focus. If using a tripod is impossible, you must carefully select the lines or edges in your composition that most prominently reveal the spiral form. Sharpness is critical because you want to convey the feeling of three-dimensional perspective that is inherent in the geometry.

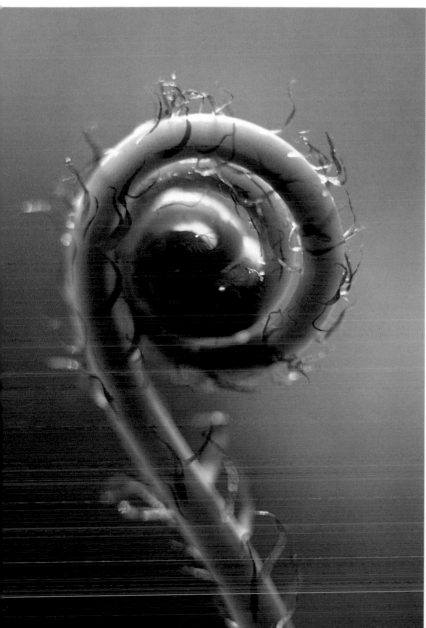

A Natica shell rolls ever larger as the mollusk within it grows. Although the center of the shell was actually closer to the lens than the shell's edges, the optical effect is of being drawn down into the center.

This maidenhair fern, unfurling on the left, is a classical symbol of spring. Shot with a 55mm lens and an extension tube, this life-size view reveals a tiny universe of future leaflets.

Circles and Spheres

Certainly nothing symbolizes nature's perfection better than the elemental circle and sphere. They are the shapes of the water drops clinging to leaves, the surface radiations of rain falling on a pond, the design of flowers and seeds, the perfection of the egg, the image of the sun, and the planet itself. Circles are formed by the forces of radiating energy, the surface tension of fluids, and the optical properties of the atmosphere. A tree's life energy moves outward in the concentric patterns of its growth rings. In cold climates mammals and birds tend to be more ball-shaped because the smaller the surface area, the less body heat is lost, and most mammals curl into a circle when they are cold in order to conserve energy. Many alpine plants also adopt circular forms to conserve warmth and energy.

One manifestation of the circle is the growth form that creates radial star shapes in such organisms as sea anemones, flowers, and some cactus plants. The radial form is an efficient way for plants and animals to protect themselves—for example, via thorns on cacti, or quills on porcupines—and to cover themselves with a maximum surface area for gathering food or absorbing light and warmth. Trees, not commonly considered radial-growth forms, are obviously so when viewed from above. Flying over a forest or looking down from a cliff reveals that each tree fills a more or less circular area by sending out radiating branches in every possible direction. On

The radial growth of a tree fern in Costa Rica is similar to that of most ferns—except that this one soars over 10 feet tall!

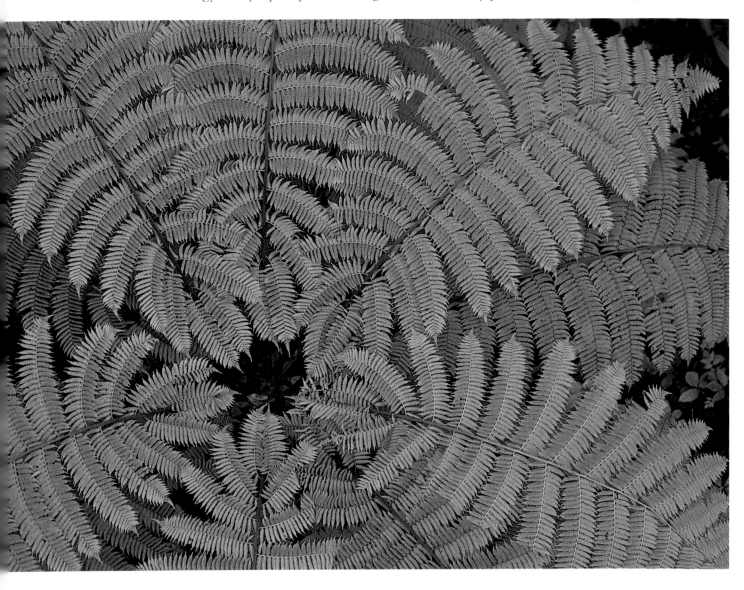

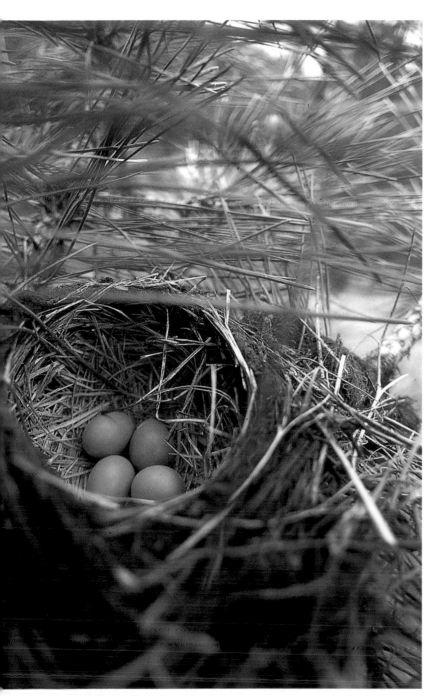

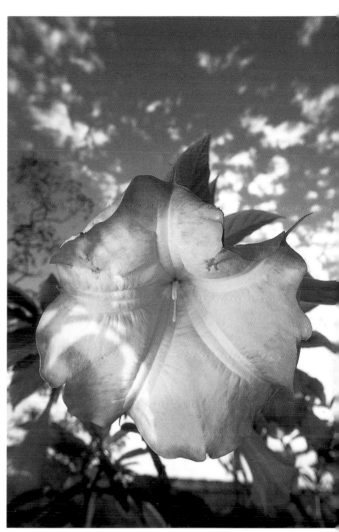

I used the great size of this datura flower to fill the frame of my 20mm lens, and still included the surrounding leaves and sky. A little fill flash from the upper left provided balanced interior illumination.

In a rare opportunity, I spied this robin's nest at eye level in a Pon- derosal pine tree growing below me on a steep slope. This enabled me to get a shot that emphasized not only the perfection of the eggs, but also the protection of the encircling nest.

a smaller scale, bushes and even mosses incorporate the same design. Certain leaves, notably maples, exhibit radial growth of their veins from a central point at the stem.

Star shapes are also common in such inorganic objects as crystals and snowflakes. Compositionally, these patterns provide a direct connection between lines and circles because the lines radiate from a central point and form a circle. This energy of natural design can create powerful photographs that draw the eye to the source of these lines and convey a graphic sense of action.

The most spectacular circles in nature are seen in the sky: the sun, moon, stars, and atmospheric phenomena around them. The sun has always been an object of wonder, fear, and worship. Great circular halos around it are created when the light from the sun passes through a high-altitude cloud of ice crystals. The light is refracted, bent by the hexagonal shape of the crystals, and the resulting change in its wavelength appears as a spectrum of light around the sun. Seeing and photographing one of these solar rings usually require an object for blocking out the sun itself. I some-

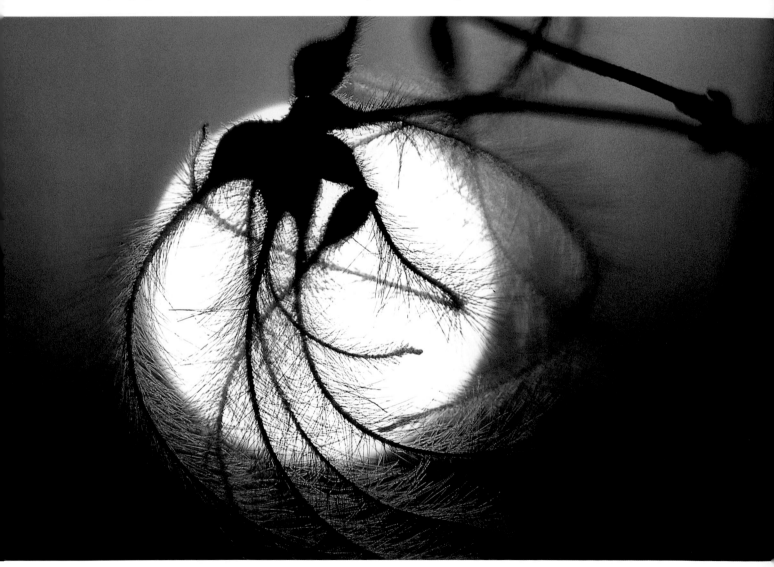

Silhouetting a swirl of clematis seeds against an out-of-focus beam of light with a wide-open macro lens created a sun-like image in this composition. Rendered large, it is too powerful a symbol to be upstaged.

times run around frantically looking for one, failing to remember that an excellent blocker, my hand, is always available.

The sun and moon, as huge as they seem when they rise or set, often don't look that huge in photographs. Getting a sense of this scale into a photograph requires using long lenses and including some part of the horizon or distant landscape as a scale comparison. Even a 500mm lens reproduces the sun as only a fraction of the 35mm frame. Exposure, too, can be a problem with such subjects. When you shoot at sunset and sunrise, one strategy is to meter the sky exposure to one side of the sun, which renders the sky accurately but overexposes the sun itself. If you shoot with a wider lens, hold a finger out in front to block just the sun while metering, then shoot (get your hand out of the way first!). In thick haze or fog, though, you can meter the sun directly. When photographing the moon, remember that it is illuminated by the sun, and actually takes the same exposure as a sunny object. A good starting exposure for Kodachrome 64 is $f/8$ for 1/125 sec., and then you can bracket for more exposure. When the moon is rising in haze or isn't full, the ambient sky light might provide the best exposure. Keep in mind that the earth is always moving, and exposures longer than about 8 sec. will create multiple images or streaking in the final photographs.

The perfect geometry inherent in circles and spheres makes composing them in photographs nearly a foregone conclusion. Even the centered "bull's-eye" framing, which many composition books warn against, can work if the image is graphic and powerful. Another compositional method often overlooked is cutting part of the circle out of the frame. This engages viewers by forcing the mind to complete the implied circle. The same effect can be used in photographs with narrow depths of field in which the circular line fades out of focus at certain points along its circumference but still conveys its shape. With smaller circular objects the patient search for the perfect, or most interestingly imperfect, sphere is a crucial component of framing and composition.

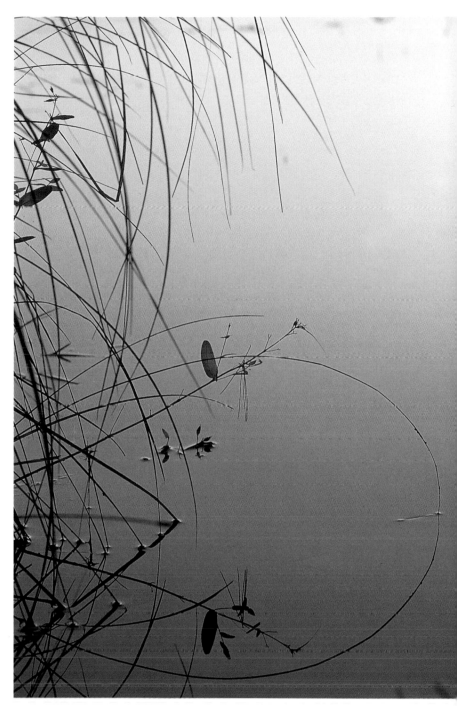

This reflection completes the circle of sedges in this image, which I carefully composed with a 105mm lens in the quiet just before sunrise. Other stems provide strong, echoing shapes and implied circles.

Triangles and Polygons

These shapes occur in a wide range of sizes, from the largest mountains to the smallest cells. Triangles and polygons evoke a graphic sense of strength, stability, permanence, and, often, mystical power.

Mount Fuji owes its symbolic power to its triangular shape, and the ancient pyramids have endured as an embodiment of the triangle's mystical characteristics. The shape's basic structure, though simple, is sound and, when viewed pointing up, always connotes strength. An inverted triangle, on the other hand, implies instability, which can also be significant compositionally. Contrasting these orientations can be effective in heightening design, as in images of jagged subjects.

Perhaps the strongest rendition of a triangle is a silhouette, which you can easily capture when a mountain is backlit by dawn or sunset. Using a telephoto lens to sandwich a range of mountains in varying degrees of silhouette against each other makes a dramatic graphic statement. Filling the frame with one triangle's full shape is especially impressive; like circles, triangles seem to gain power when centered in a photograph. Triangles are also effective in tightly cropped compositions when the lens moves in close until the shape overflows the frame and cuts off the outer points. This lends a pictorial tension to the image, forcing viewers to complete the shape in the frame.

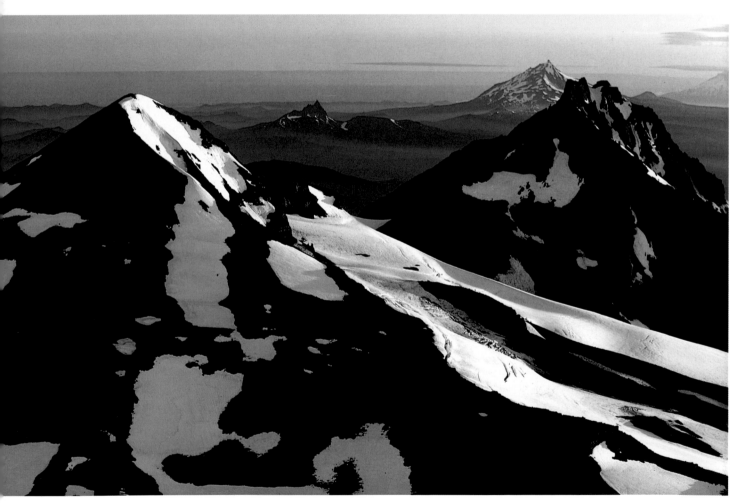

From a mountaintop, Oregon's Cascade Mountains are enormous triangles receding in the distance. The irregular snowfield patterns on their flanks off-sets the power of their volcanic shapes. A polarizing filter on a 200mm lens eliminated unwanted haze and accentuated the white snow.

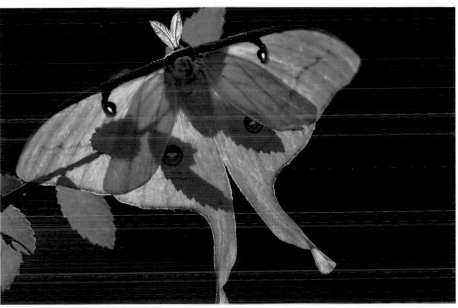

Like bright polygonal road signs, maple leaves in autumn are hard to ignore. I shot these in Oregon with a 105mm lens.

The luna moth, backlit on the left, has a shape similar to the leaves it ate when it was a caterpillar. I photographed this moth in East Texas with a 105mm lens and an extension tube.

The multi-angled shapes of some rocks, flowers, leaves, seeds, and sea creatures are impressive and evocative polygonal subjects when isolated by the camera. These three-, five-, and six-or-more-sided shapes often occur in interlocked arrangements, creating very strongly organized designs. In rocks this interlocking might comprise the fragments of a single larger stone or the patterns created by the geologic processes of compression and stratification.

Like spiral shapes, you usually must photograph polygons in sharp focus; this emphasizes their pattern more graphically. Be aware that this might require great depth of field, as well as careful adjustment of your tripod and camera in order to keep them parallel to the subject. When deciding how many shapes to include and how to frame them, remember that the human mind likes to make its own connections in visualizing an underlying organization: for example, the way in which groups of stars are mentally configured to become constellations. In your composition let viewers "connect the dots" from polygon to polygon, to see what final shape the composition makes. Curving lines, triangular and circular arrangements, and off-center groupings result in the most pleasing compositions.

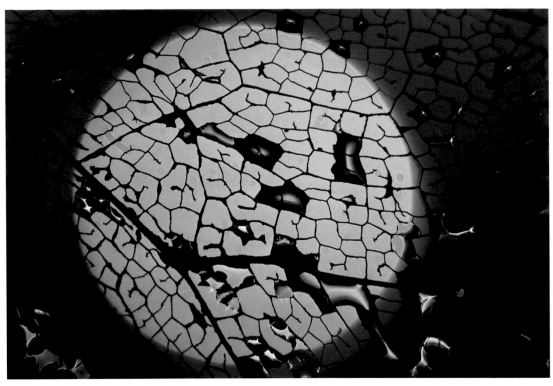

The cellular pattern of a skeletonized deerfoot leaf, photographed life-size on a forest floor, reveals an abstract pattern of polygonal holes, some filled with water, backlit by the sun.

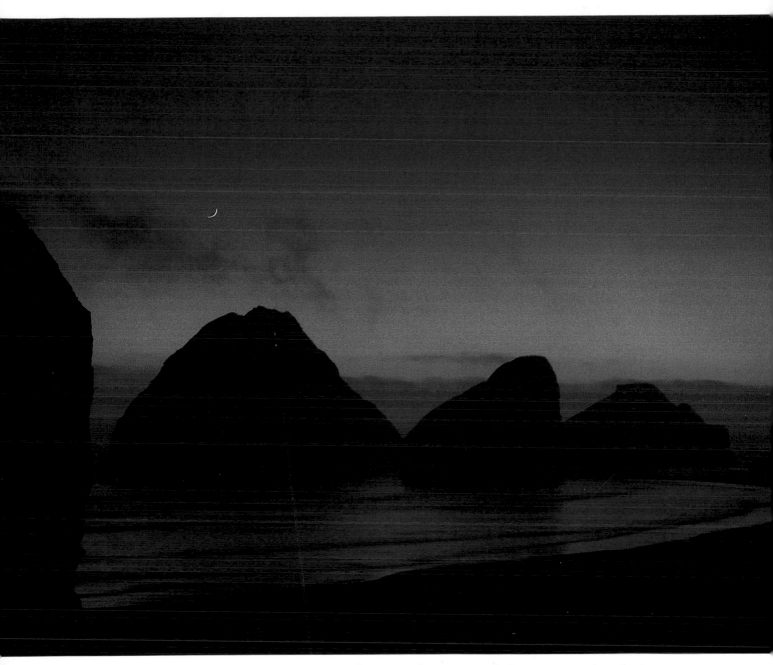

Brooding sea stacks are scattered along Myers Beach on the Oregon coast. Captured at dusk beneath a crescent moon, their triangular shapes rise from the surf like beached behemoths.

PERCEIVING PATTERNS

The realm of pattern is an organization of shapes that repeat and combine in a photograph. While thinking about how to compose the basic shapes you've learned to recognize, remember that rhythmic repetition and point of view are important. Consider, for example, the ways you could approach photographing a range of forest-covered mountains. From an aerial perspective, you would perceive the overall pattern and textures of ridges, fields, and streams. If you were to view the scene from a lower, more oblique angle, the pattern would reveal a series of repeating ridges stretching to the horizon. If you were to climb to a ridge top and look across a valley, the shapes of the trees would become the primary image pattern.

The forest itself is a rich source of patterns, such as rocky slopes; a tree's repeating branches, needles, and bark patterns; and the accumulation of things on the forest floor. Richly textured photographs that include whole fields of pattern are fascinating to look at and can elicit a wide scope of personal, if sometimes abstract, feelings. Patterns speak powerfully of the underlying order in the universe and of the continuation of life's processes. Whether that connotation is positive or negative depends on the subject itself. A field of green, star-like shoots of grasses is a reminder of endless cycles of birth and rebirth, while a pattern of cracked desert mud suggests dark images of drought, exhaustion, and death. How you choose to interpret patterns will involve thinking about how you react emotionally to many of them.

I've grouped this section into two types of pattern arrangements: positional and inherent. Positional patterns are those you construct through a change of viewpoint and framing to create a photograph. Inherent patterns occur naturally; think of a peacock's plumage, a honeycomb, or the arrangement of petals on a daisy.

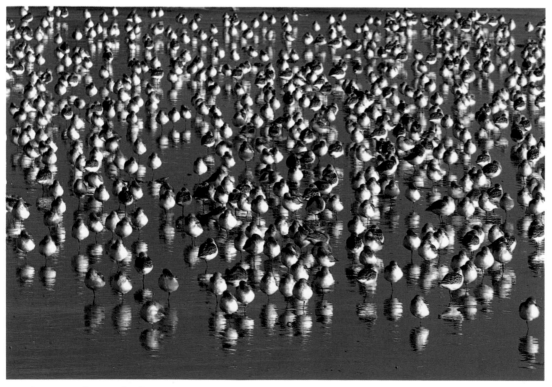

Sandpipers gather on the Oregon coast, creating a positional pattern.
Their reflections change rapidly with movement, either theirs or yours.
To achieve maximum depth of field I set my 300mm lens at f/22.

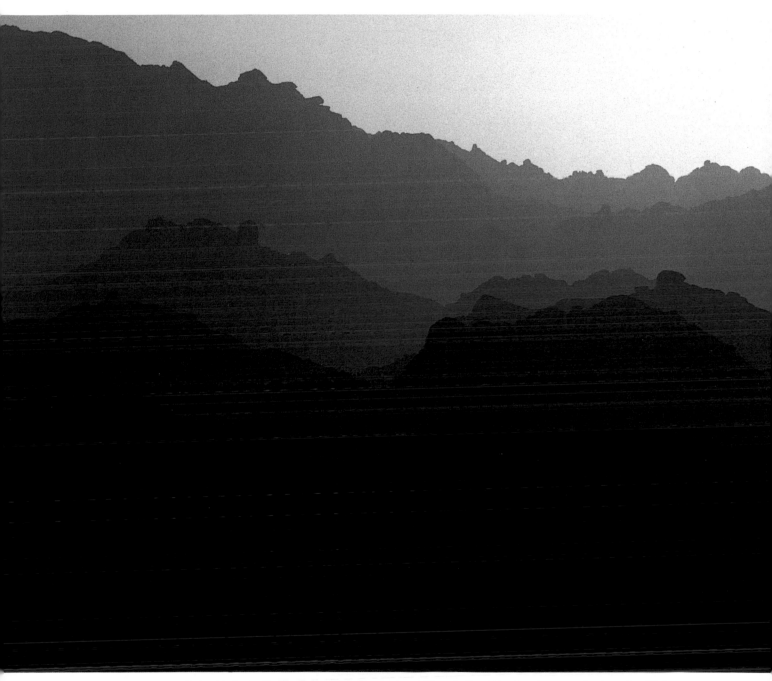

The mountains of Egypt's Sinai Peninsula in stark, dusty backlight produce an inherent pattern when viewed from the same place daily; however, a shift in the camera's location would create a change in the pattern, so it could also be considered positional. Here, a 200mm lens compressed the distance between the mountain peaks and emphasized the congruent shapes of the ridges.

Positional Patterns

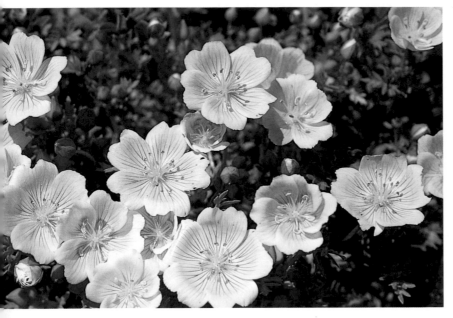

Looking directly down at these flowers, I grouped them in a pleasing arrangement, a pattern entirely dependent on my viewpoint.

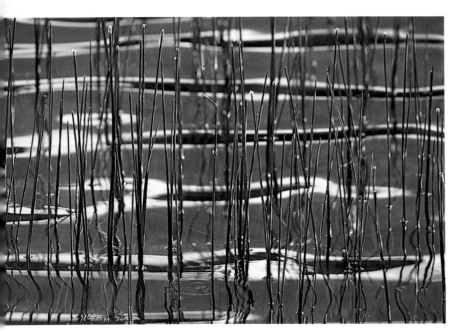

Using a 105mm lens, I moved along a lake shore in Oregon's Wallowa Mountains until I found a plane of reeds that I could align with the film plane, thereby ensuring that they would all be in sharp focus against the waves behind them. The shallow depth of field was a concern because I had to use a shutter speed of 1/250 sec. to freeze the water's motion.

As you move through the world, the landscape shifts before your eyes and the visual relationships of perspective and scale among objects changes. From certain viewpoints, the ridges in a mountain range echo each other's shape, the trees in a grove seem to dance in synchrony, and wildflowers bloom naturally in a symmetrical arrangement worthy of an ikebana master. Active nature photographers seek out patterns by carefully observing these strong shapes and imagining how they might look when viewed from a different perspective. A scattering of stones or a small group of flowers might call for only a closer view and different framing to create a striking photograph emphasizing their shapes, colors, and textures. Perhaps on closer view you might feel the subject needs either more angled light or a return visit later when more flowers are in bloom. Finding strong patterns in larger scenes and landscapes often requires more work. To get a variety of compositional perspectives, move around the subject, observe the light and atmosphere in the scene, and seek a higher or lower viewpoint.

Positional patterns are often revealed from above. Flying in aircraft and climbing mountaintops are great ways to see patterns, but even shooting while standing on a small boulder can transform your view of a prosaic meadow into a wonderful design of grasses and flowers. Starting before dawn and working until sundown will enable you to capture all the magical changes of a full day's light creating different patterns. You'll also get better images if you shoot with telephoto lenses because they'll fill the frame with just the composition you want.

If the elements of your pattern are near the camera, you'll find it more difficult to keep them all in focus without using small apertures and a tripod to minimize vibration and movement during long exposure times. When photographing positional patterns, I've learned to shoot a few images even when the scene isn't perfect. This kind of practice acts as a visual sketchbook that, along with a scribbled note, helps me remember the scene and plan to shoot it again.

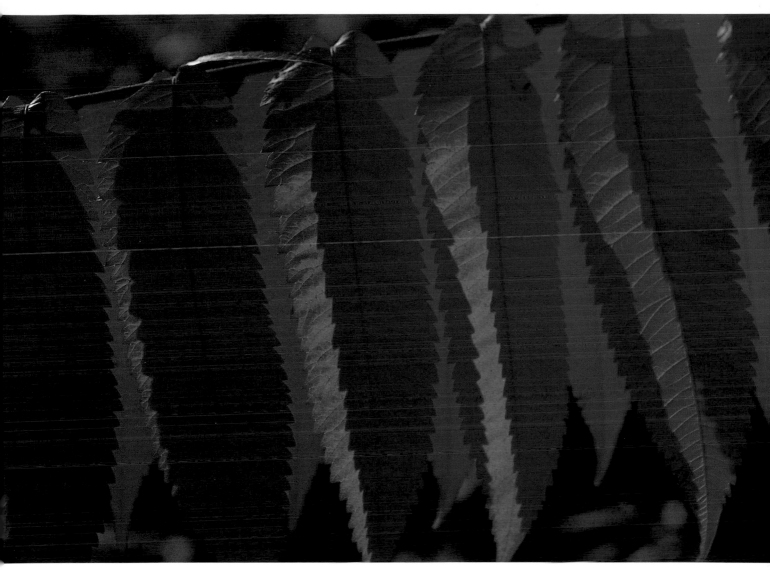

While the pattern within each sumac leaflet is inherent, the arrangement of the leaves—their serrated edges, shadows, and backlighting—makes this a positional pattern.

Inherent Patterns

Nature itself designs these patterns, which include the spots on a giraffe, the flaky bark of a eucalyptus, the spines of a pineapple, the scales on a salmon, and the crevasses of a glacier. Unlike positional patterns, you don't have to search for inherent ones. Still, photographing them involves as many creative decisions as shooting positional patterns. The major problems are getting all of the patterns in focus and deciding how to compose separate elements of each pattern in the picture.

The seedpods of the desert shrub Senna polyantha were just out of reach of my regular closeup lens, so I used an extension tube on a 300mm lens to isolate this one. I was interested in the X-ray effect of the backlighting and the imperfect pattern of pollination it revealed.

A design's expanse of pattern is strengthened when all its elements are in sharp focus. Out-of-focus areas detract from the overall impression of the surface and sometimes interrupt the actual repetition of the pattern. Be painstaking in keeping your camera parallel to a pattern's flat surface, and use the smallest aperture possible to get maximum depth of field. A tripod is often essential.

Other factors that affect a pattern's sharpness and legibility are the angle and intensity of the light falling on it. If the pattern has raised surfaces, they might not show in indirect light, and strong overhead light can render any surface texture nearly featureless on two-dimensional film. Luckily these two conditions are rare. Even the flat light of a completely overcast sky will at least cast more light on one side of a subject. I've learned that patterns with very crisp edges often look even sharper when illuminated by direct, angled sunlight or flash, while softer, rounder-shaped patterns are enhanced with indirect light that emphasizes color and shape rather than texture. For example, indirect light is best for photographing eucalyptus bark because it is smooth with large patches of earth tones. On the other hand, the deeply fissured roughness of hemlock bark looks better when it is sidelit. When your subject is brilliantly sunny and you want a diffused light effect, you can always throw a shadow across the subject with your body or camera bag. Another solution is to use a diffuser, such as a translucent piece of white plastic or a white umbrella.

Another personal, aesthetic decision is the number of pattern elements to include in the picture. Your subject can comprise three elements or thousands. Consider whether you want to evoke a sense of infinite space, in which case you might want to include many elements and let some of them be cut off by the frame as if there were too many to fit. Otherwise, you can compose so that some go off into a horizon line to suggest "endlessness." Don't over-organize your composition; this can yield a photograph that is static and looks staged. Vary your compositions to keep them interesting. You can, for example,

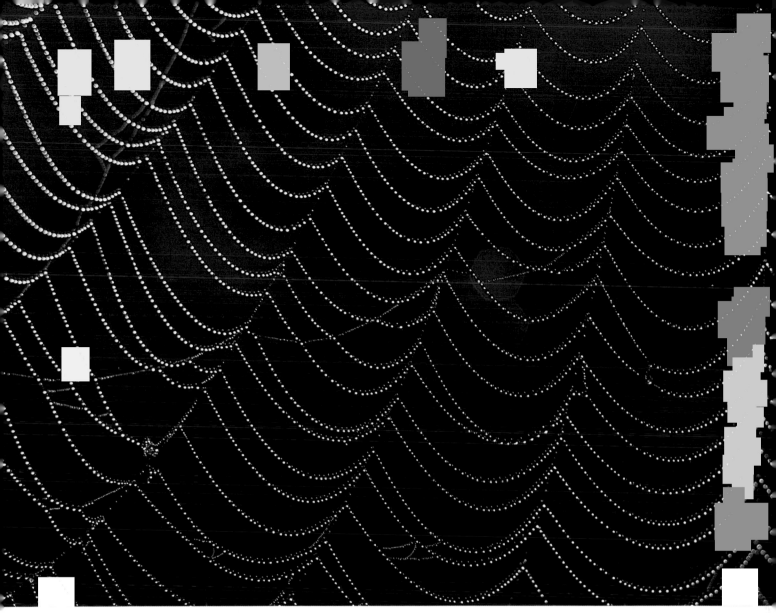

Each "snare" strand in this web was draped by a spider traveling along the non-sticky radial strands. Overnight, dew formed more heavily on the sticky snare strands. I used a tripod to photograph the web at dawn, setting my 55mm lens at f/8 to ensure adequate depth of field.

photograph many inherent patterns, such as a group of wildflowers or multi-colored stones on the beach, to look like vast fields.

You can't help but marvel at the similarities in the repeating fields of polygons and lines created in groups of cells, flower buds, animal markings, bubbles, crystals, shells, scales, and tightly packed sunflower florets. These definitely aren't all parallel structures, but the pattern of construction for all of them begins at the molecular and cellular levels, and creates both pattern and texture.

A very basic construction principle shows up in nature anywhere cells, vesicles, and discrete cylindrical packets of energy are formed and begin interacting. This is the

trend to conserve energy. Energy conservation isn't a simple process, says Philip Ball in his technical book *The Self-Made Tapestry*, and it has many outcomes. Nature wants to use the smallest amount of material to build or hold the greatest amount of stuff, and it usually works with thin surfaces that enclose a space, like bubbles and cell membranes. A circle or sphere actually contains the largest area within the shortest perimeter length, but there are spaces between circles or spheres when they group together. If the circles or spheres (or cylinders) pack together efficiently, they have flattened sides and resemble hexagons or complex dodecahedrons, and still enclose the greatest space. Changing

the amount of fluid between cells or adding deformation stresses leads to other efficient, minimal membrane shapes that look like saddles and wings. Living things use these shapes to create templates for structure, such as the hexagonal design of honeycombs, the holes in sponges, the shape of leaf cells, and the skeletons of diatoms.

Other patterns exhibit triple junctions due to other processes. Think of shingles on a roof, for example. The crack between two shingles is covered by a single tile on the next layer. This arrangement keeps the rain out of the roof and waterproofs it. In nature this arrangement is effective for fish, reptiles, and birds, all of which need water-shedding skins. The triple junction also exists between sets of ripples of wind-blown sand, and the ridges on a saguaro cactus. These inherent

patterns are the maps of the growth process that must balance the flexibility and stretch of the material they're made from with the need to cover their surfaces evenly. For animals, camouflage is also an overriding requirement that overlays structure with another set of patterns.

Some of these processes work sort of in reverse, in drying and contracting mud, paint, crystals, lava, and tundra soil. As the material undergoes the stress of contracting, cracks start at many weak points at once and propagate following the underlying structure of the material. This structure commonly contains triple junctions, which the cracks follow, turning at 120-degree angles and creating rough polygons and hexagons. (Keep in mind the basis of pattern genesis while reading the section on textures on page 58.)

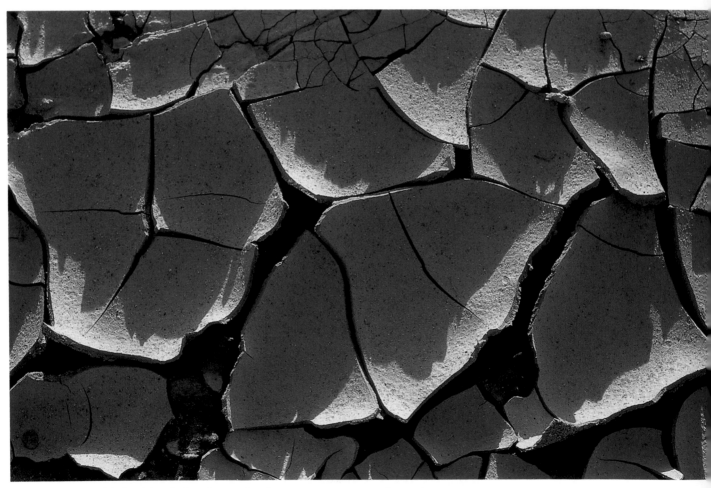

In this pattern highlighted by Alaska's low midnight sun, you can see major and minor systems of cracks. These came about when large, thick plates first separated and then suffered cracking themselves from continuing stresses of contraction. The resulting sets of irregular polygons meet mostly at triple junctions.

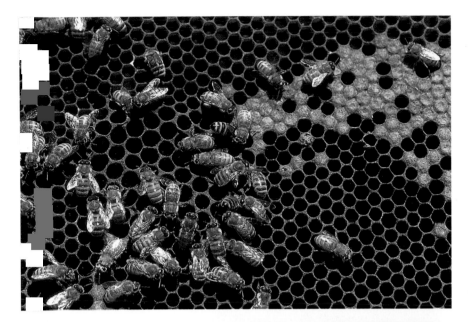

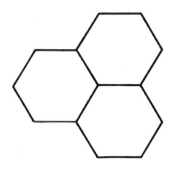

A beehive's storage cells are a classic example of economical, space-filling construction, illustrating the close packing of spheres and cylinders. The diagram shows a perfect hexagonal pattern formed by triple junctions.

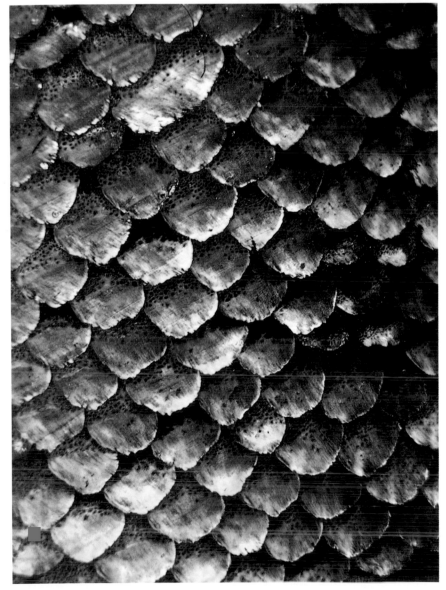

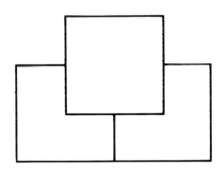

The shimmering fish scales from a king salmon in this photograph display another kind of triple junction, illustrated in the diagram next to it.

PATTERNS IN COLOR

These rosehips demonstrate a rich palette from the red end of the spectrum; a fringe of frost sets off their emotional warmth. Red is a symbol of ripeness.

Color is a daily miracle of the universe. The thousands of different colors that we recognize, and that give meaning and definition to everything we see, are created by only a fraction of the flood of radiation constantly bombarding the earth. These light waves aren't absorbed by the atmosphere like most other wavelengths, but are directed onto the earth's surface, and plants and animals have evolved natural ways to use this direct solar energy in the process by which they grow. We don't often experience the color of light directly; nearly every color we perceive is just a small part of the sun's total spectrum, left over after the rest of the wavelengths have been absorbed, reflected, or refracted. An object we see as red, for example, has absorbed the energy from the light waves of the yellow, green, and blue portions of the spectrum. We do see some color directly, such as the sun at midday, glowing coals, and light bulb filaments. And of course, all colors are often seen after being reflected from other surfaces.

Our perception of color evokes immediate emotional and graphic responses. All of the natural designs highlighted in this chapter would make a strong impression if photographed on black-and-white film. But the same subjects are given added meaning and new visual power by using color. Color is cru-

cial to identifying the season, time of day, and place. The shapes in an image might describe the objects as leaves, but colors tell us if it is fall or spring, midday or sunset. Color imparts information. A Pacific tree frog, which is normally green, might be identified in a black-and-white photograph, but its unusual blue color, which is seen in winter, would be lost. Color is also clearly important in bird plumage since many similar species differ visually only by the arrangement of color on their feathers. Many animals and birds, such as arctic species of ptarmigan and weasel, change color during the year in response to climate changes or mating cues. Colors also underscore the overlapping effect of our senses because they can make us think of tastes, odors, sounds, feelings, places, and people. For photographers, this range of color means that it can be treated as an overlay, a separate realm of pattern produced by color alone.

Three important attributes of color—hue, value, and intensity—create its appearance and evoke our emotional responses to it. *Hue* indicates the position of the color on the spectrum; it is the name of the color, such as red, burnt sienna, or purple. Although it is estimated that the human eye can discriminate among several million hues, names exist for only a few of them. *Value* is the lightness or darkness of a color, and *intensity* refers to its saturation.

Hues are often described in terms of warmth or coolness. Reds, oranges, and yellows are warm; blues, purples, and greens are cool. Warm colors are stimulating, and seem immediate and more urgent. Think of the heat from a fire, or a red stop light. In contrast, cool colors seem quiet, restful, and distant. Imagine the blue of the sea and sky, or green grass. Names for colors might be spare, but the emotionally and symbolically rich language of colors is an impotant part of any photographer's vocabulary.

Red might be the most important signifying color. In fact, linguistic studies have revealed that it is often the first color named as languages develop. Linked emotionally to blood, battle, sex, heat, revolution, and rage,

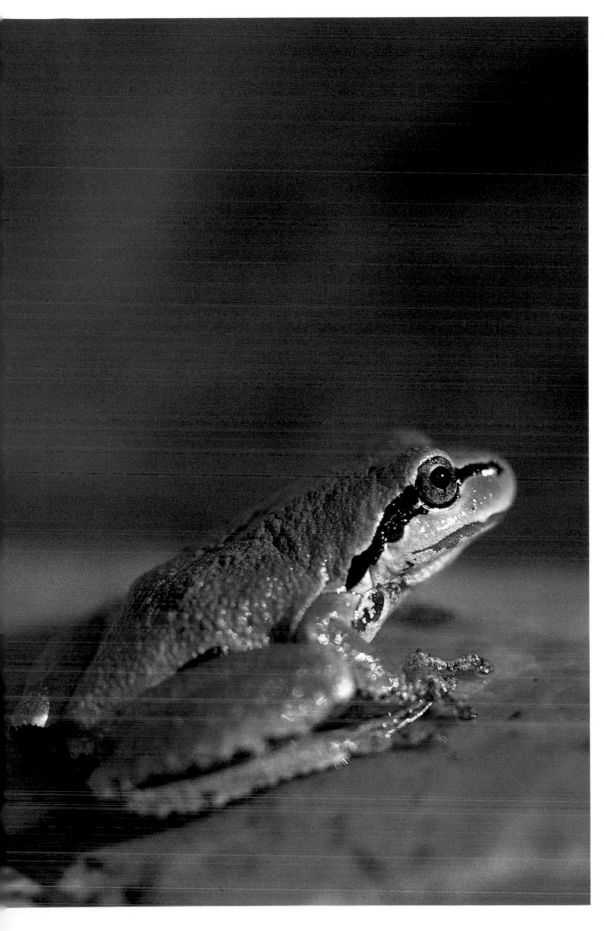

The Pacific tree frog's colors can vary from season to season. Here, its blue skin mimics the deep blue shadows of winter before spring and summer's green becomes the dominant hue again.

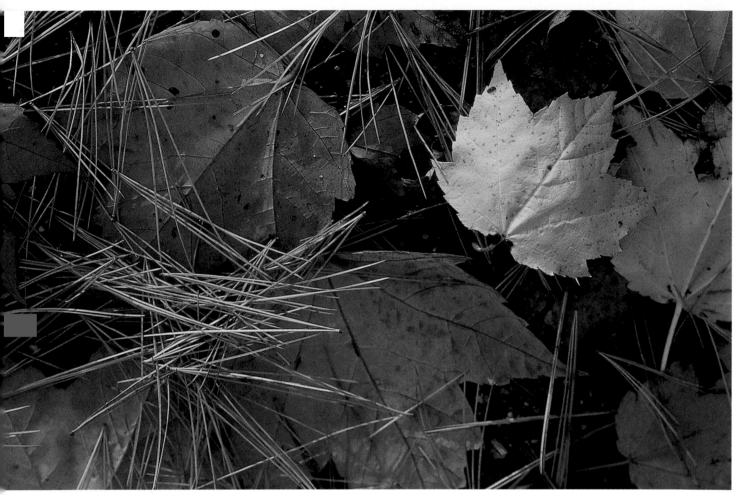

red is associated with excitement and danger. In photographs red is aggressive. It seems to push ahead of other colors and make objects look bigger. Just like a crimson bird or perfect rose, it attracts and halts the eye. Red is also emotionally uplifting and dramatic. The subject matter in which it is found is replete with positive meanings.

Orange and brown are earth tones. Orange can be luminous in flames, monarch butterflies, and garden daisies, but most of its emotional heat is stolen by red. More often orange is subdued, as in the warm ground colors of clay and sandstone, pastel azaleas, and the beautiful hues of the afterglow of sunsets. Many neutral colors, such as tans, grays, and whites, pick up a pleasing brown-orange tint when you photograph them bathed in the last rays of the sun. This color interaction can give new life to sub-

jects as diverse as great mountain cliffs and minuscule frost crystals. Earth tones of brownish gray are seen in the colors of tree trunks, autumn and winter plants, and many animals. These colors are comforting emotionally and symbolize the solid ground.

Yellow is wild, bright, vivacious, and active. It is instantly linked in our minds to gold and the sun, symbols of wealth and life. When yellow is very pale, it seems to recede, and it might evoke cowardice and sickness. Like red, bright yellow jumps out of a picture irrepressibly. Nature photographers are attracted to what I call "Mother Nature Yellow," the particularly brilliant shade of yellow that is common to so many birds, butterflies, tropical fish, flowers, fruit, fall foliage, and, of course, the sun. Less intense yellows are found in ripening grains, sand dunes, rock formations, and the pelage of wild cats.

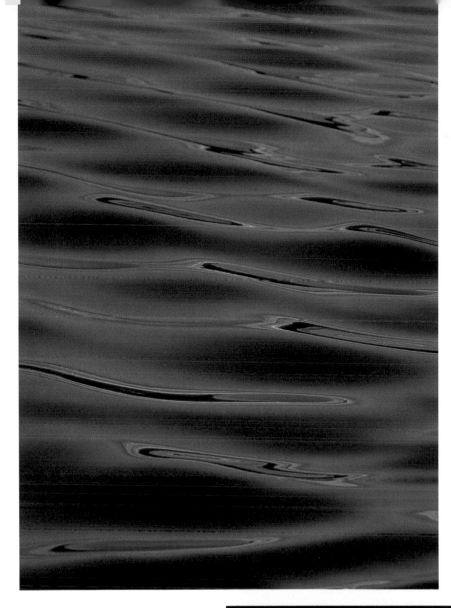

Orange and brown are a pleasing combination of colors, and are associated with the earth. Here, the reflection in the ripples on a bay at dawn is mesmerizing.

"Mother Nature Yellow" is my admiring term for the strong hue seen here in the sunflower and the grasshopper. I accentuated the power of the color and shapes via tight cropping and a touch of fill flash.

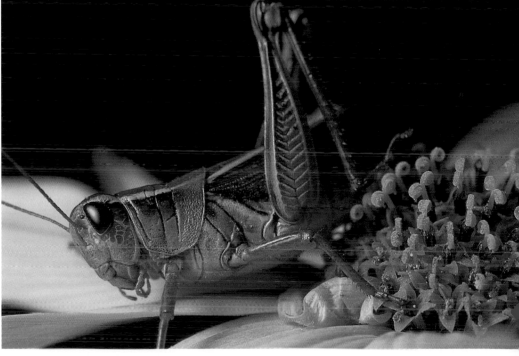

Green is a universal symbol of life on earth. This color brings out feelings of hope and wonder: in the discovery of an unexpected single green shoot or an entire landscape of rich green plants in the forest. Green has a great range, from the light chartreuse of lichens, to the blackish greens of fir-tree needles. Green appears in some unexpected places, such as the aurora borealis, iridescent beetles, and even some flowers. Although it has a few unsettling connotations—little green men; green with envy; green around the gills—it is a very restful color and is ever more popular as a symbol of environmental riches and causes.

Blue is the color of the sea and the heavens, and like green, a symbolic color understood instantly. Blue reaches deeper into your mind, reminding you of cool temperatures, the evening hours, sadness, excellence, and spirituality. It is also a powerful visual cue suggesting distance and solitude. Blue seems to recede, yet when seen against a neutral background, such as a bluebird in a dark forest, it is stunning. Nature abounds with blue: wildflowers, the microscopic structure of feathers, Morpho butterflies, the iridescence of some insects, and the ever-present sky.

Violet is the hue at the far end of the color spectrum. In some ways this color is more intense than blue, yet it is allied with red and purple. These colors occur infrequently in nature, and so they are more striking when seen. They can symbolize

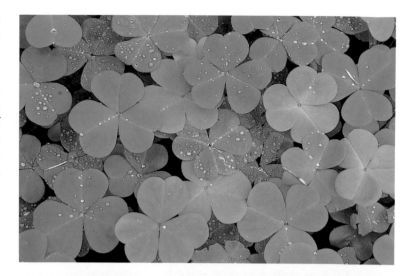

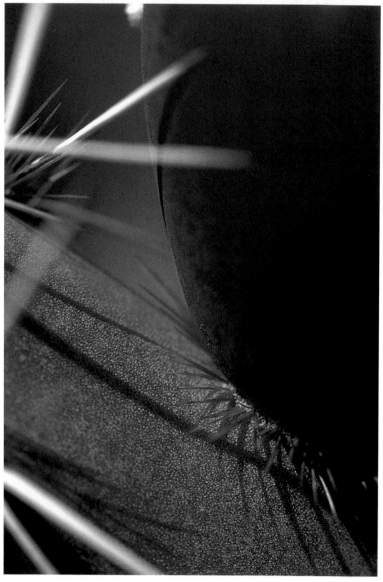

In the deep shade of Oregon's coastal forest, oxalis forms green carpets of clover-shaped leaves. I shot this photograph from directly above the subject with a 55mm lens.

If you've ever wondered about the genesis of the contrasting colors seen in desert architectural styles, here is a hint. This shot of a prickly pear fruit against the rich green of the cactus pads is a tight composition that is more about the colors than the cactus itself.

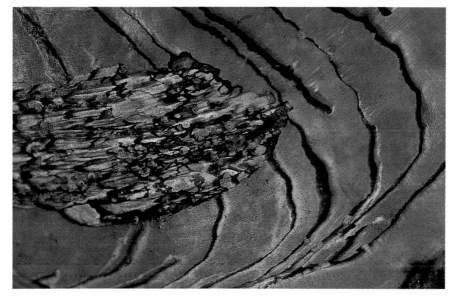

The micro-thin layers of calcium carbonate that make up the nacre, or mother-of-pearl inner shell, of the red abalone are not only extremely hard, but also diffract light, creating the shimmering color effects.

Nature's palette contains many unusual colors; few are stranger than those in metal ores. This sample from Arizona contains copper ore, creating the blue and turquoise also seen in gemstones.

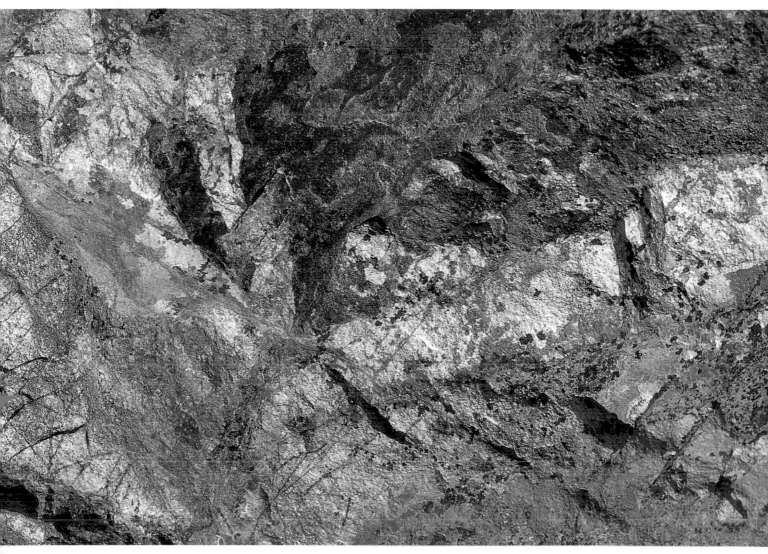

mourning, richness, and otherworldly things. For a few years following a volcanic eruption that reaches high into the atmosphere, sunsets are incredibly rich in violet colors due to the dust of the volcanic steams.

White and black are not spectral colors, of course, but are rather the presence and absence of all colors—pure light, pure night. Black and white used in color pictures can carry powerful messages. White symbolizes the purity of fresh snow, the innocence of a lily, the mystery of the moon, and the peace of a dove. Sometimes white light itself is the subject, as in pictures of the sun's rays piercing through fog or of spectral reflections radiating from icebergs. However, white light surrounding a color in a photograph tends to wash out the purity of the color; also, brilliant white highlights can distract the viewer's eye from the subject.

Black, though it often evokes negative symbols like evil, death, the unknown, and the dark void of infinite space, shouldn't be underestimated as a rich source of color in photography. Black backgrounds accentuate colors, and underexposed shadow areas in a photograph often strengthen the design. Blackbirds and basalt mountains are powerful shapes when seen against the colors of their surroundings. Backlighting can create a black silhouette of almost any natural object, and silhouettes are an extremely effective way of extracting the symbolic essence of a natural shape, such as a mountain, a tree, or a flying bird.

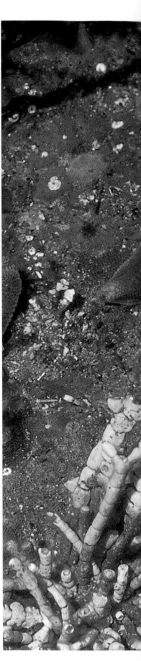

One effective way to use color in a design is as spots against a contrasting or neutral background. Here, small patches of Xanthoria elegans lichen appear as drips of paint on a tundra stone.

Wild combinations of colors are common in the ocean and its shoreline tidepools. At Point Pinos off Monterey, California, I photographed this bat star grazing across lavender coralline algae and a red bryozoan. I made this shot using a Nikonos underwater camera in shallow water in sunlight.

Value and Intensity

Value is the lightness or darkness of a color. High-value colors are pastel in shade, such as pink and pale lavender; low-value colors, such as brick red and dark purple, contain more black. A picture dominated by high-value colors is called *high key*; conversely, a dark composition is called *low key*.

Intensity refers to a color's brightness and purity, a quality also called *saturation*. Saturated colors seem more immediate and exciting than their less intense counterparts, even when they share the same value. For example, in an image of a yellow rose, the interior of the flower has a darker value because the petals are fresher, and the interior is more saturated because less light reaches inside. At the same time, the outer petals of the rose have a higher value and lower intensity because the light that reaches them washes out the color. These two areas of the image give different impressions of the rose: a rich vibrancy inside contrasting with a pastel delicacy along the edges.

A photograph's message can be dramatically changed by manipulating a color's value and intensity through under-and overexposure of the image, and by photographing it under different lighting conditions. I often recommend that students experiment by shooting a single scene at every aperture on their lens, starting at *f*/8 for a "normal" exposure, and changing the apertures without changing the shutter speed. This exercise shows not only the change in a color's value as the exposure becomes darker, but also the exposure latitude of color film. It is possible, for example, to intensify the color of light pastels by underexposing the film, which literally keeps the color from burning out.

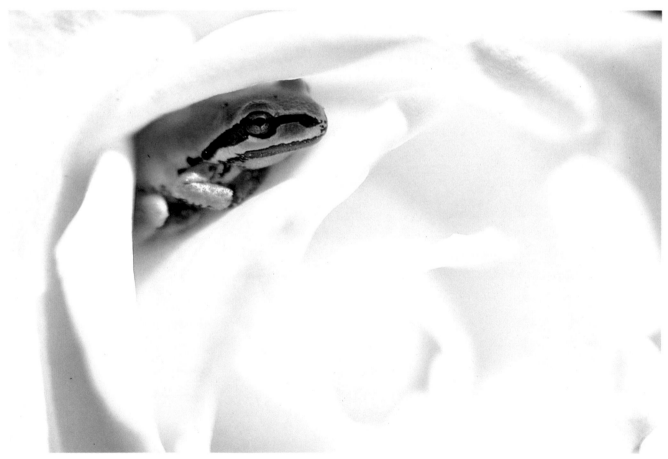

This little frog provides a surprising contrast to the high-value delicacy of the pale yellow rose.

Overexposure and shallow focus created
this expressionistic composition of grasses
and vetch flowers, a high-key study in
low-intensity colors.

The high-intensity, saturated colors cre-
ated by underexposing this autumn
scene have similar or higher values than
the pastels in the picture above.

Using Color and Light

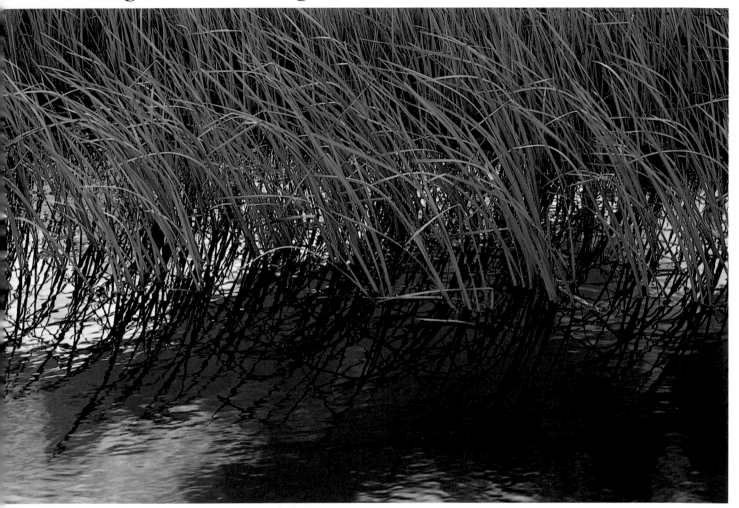

As you photograph more natural patterns, you'll discover that the nuances of value and intensity within a single hue are altogether different from the distinctions your eye makes between different colors. Just as it is important to understand how patterns work together, as a photographer you must also study the relationships between colors. The most important relationship is their relative position on the color spectrum. Hues that are close to one another, such as blue and green, or orange and red, have an affinity for each other in your mind. Seeing them together seems natural and is usually pleasant. But when juxtaposed with colors from opposite ends of the spectrum, such as blue with orange, or red with green, the contrasts are richer; these colors are called *complementary*.

The effect of combining them in an image can be jarring, creating tension and energy.

The classic example of complementary colors is red and green. The tension and vibrancy between these complementary colors is actually a physical phenomenon. Light from the red end of the spectrum is created by longer waves than those that carry the blue part of the light, and our eyes, therefore, focus on these colors slightly differently. The constant movement of the eye muscles, responding to the colors' different wavelengths, creates visual tension. Artists and photographers frequently use complementary colors to create energy and surprise in their work. Many television commercials employ intense oranges and blues to capture your attention.

This quiet composition shows how neighboring colors in the spectrum, such as blue and green, can be combined with gentle shapes, reflections, and curves to make a restful statement.

This picture employs complementary colors, blue and orange, to produce an exciting, tension-filled exercise for the eye.

One of the most important skills to develop is a sensitivity to the precise color value of light falling on a subject. An obvious change can be seen on partly cloudy days when an object is lighted first by direct sunlight and then by diffused, indirect light as a cloud passes over. The light intensity drops to about one-quarter, and the light source is now the blue sky, not the yellow sun. Although you see the shadows disappear, your mind tends to ignore the optical shift in color perception because it "knows" how the colors are supposed to appear. Film, however, has no such built-in color adjustment, and the difference can be dramatic. In fact, the change from hard-edged color brilliance of direct sunlight to the softer values of shade can be remarkable.

Though indirect light softens color attractively, it also tends to dilute the impact of the whole image because of the shift toward blue light. One solution is to use an 81-series filter to add more warmth (decreasing the blue cast) when the subject is in shade. A positive aspect of shade is that it saturates any color, or deepens its intensity. Colors are changed also by early- and late-afternoon light, as well as by any smoke or fog in the atmosphere. Water on a subject creates a similar color change by bringing out and developing spectral highlights and adding reflections. Rocks, shells, and leaves lose color when they dry out, but when moistened by rain or the ocean, their hues deepen and appear more saturated with color. This is a good reason to shoot on soggy days.

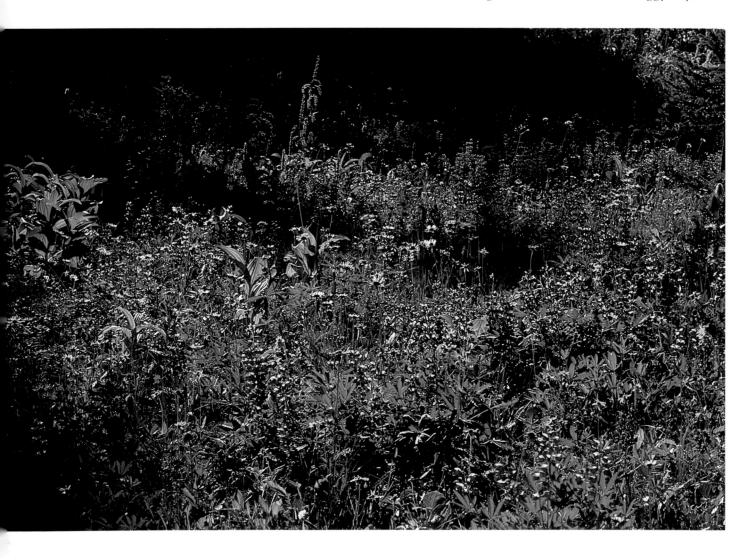

I used the golden light of the rising sun over the Florida Everglades to set off the delicate pattern of dew and the translucent white petals in this image of a spider lily.

I made the photographs below and on the opposite page moments apart in the same field of wildflowers in British Columbia. These shots illustrate the color differences between an exposure made in direct sunlight (below) and one made in the bluer light of the sky when the sun is hidden by a passing cloud (opposite).

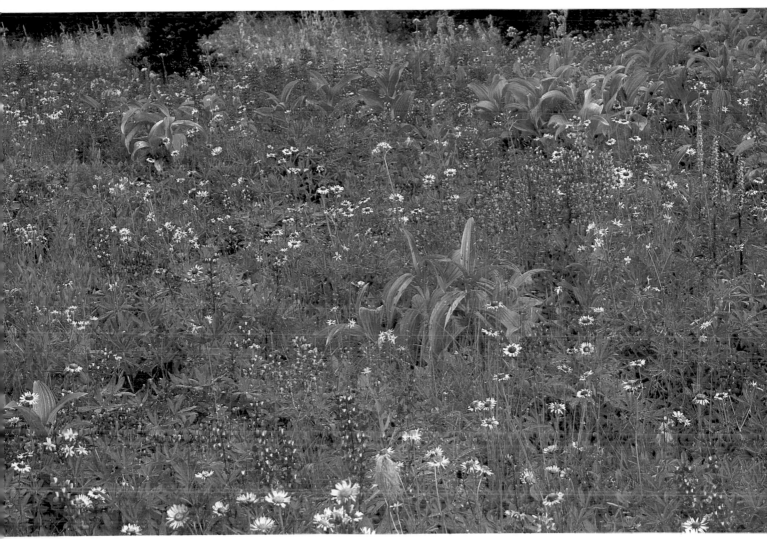

Don't overlook the background in a photograph when you shoot, even when it contains no colors to add contrast. The most powerful way I know to accentuate a color or shape in a scene is to place it against a dark, monochromatic background. Shadow areas behind sunlit objects appear black on film because the light on the object is many times greater than that of the shadow area. Slide film's exposure latitude for under- or overexposure is no more than five apertures in range; print film has a little more. Small amounts of color also stand out when they are placed against monochromatic backgrounds. Red is a particularly effective color to work with in an otherwise black, white, or gray composition. Because red is always an attention-getter, a little goes a long way.

This single red apple, which I photographed after a snowfall, conveys many messages: a harvest memory, a holiday greeting, and a promise of spring.

Here, some friends knelt down to block the sun for me, thereby casting the shadow behind these avalanche lilies.

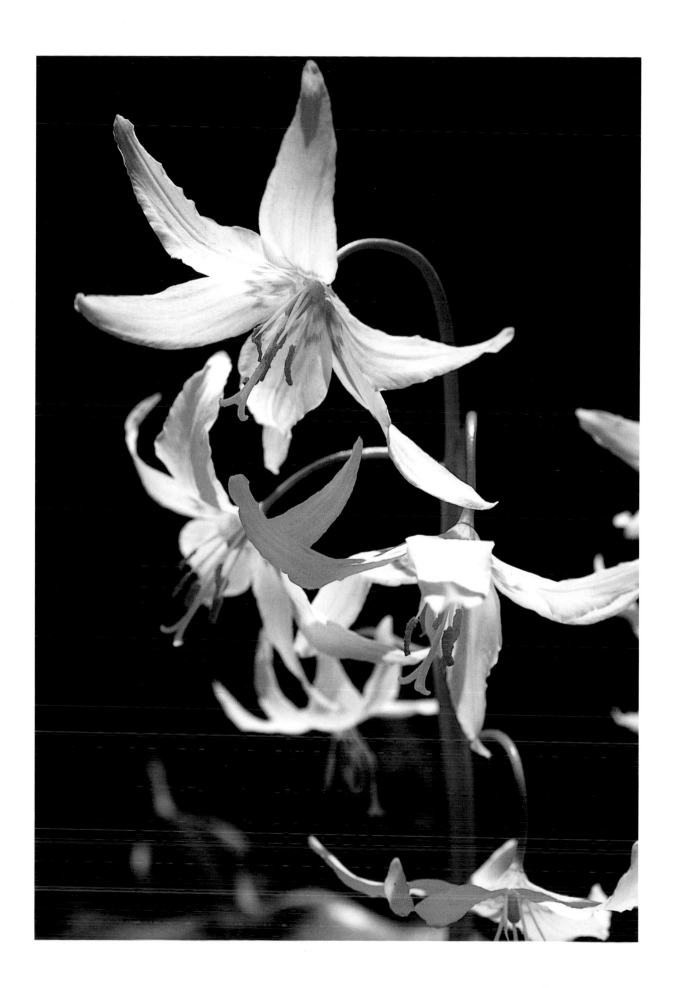

ANALYZING TEXTURES

Shooting with a 300mm lens from a promontory overlooking the Pacific Ocean, I captured the texture of ocean waves in setting sunlight. In this closeup, the water resembles the skin on a piece of fruit.

There is often a fine line between pattern and texture. For me, when a pattern becomes so small that its individual shapes are less important than the overall impression of its surface or tactile form, it has become a texture. Scale is an important element of this difference. For example, the tiny texture of mosses might resemble the tree patterns of a forested mountainside, yet that same mountainside, when viewed from a great distance, becomes a moss-like texture of greens.

A single orange can be a dramatically shaped sphere, but in a crate filled with others it becomes part of an evocative pattern of color and circles. When viewed close up, the orange's peel looks like a rippled, sunset-laden sea. Then cut the orange open,

and you'll enter yet another world of texture. I doubt that you could exhaust the picture possibilities of any single natural shape; the patterns and textures offered by the world are innumerable. Everything has some texture. Even a still pond is not glass smooth: closer inspection reveals a surface dimpled with motes that float across reflected patterns of the surrounding landscape. Unlike pattern, all texture is inherent, created by nature in surfaces or reflected by the underlying structure of an object.

The angle and quality of light affect texture and pattern in similar ways; however, composing images of texture is sometimes a much less structured exercise than that required for other subjects. This is because a change in scale—larger or smaller—often transforms a normal-sized subject into something with more abstract possibilities. Pictures of texture are usually more abstract also, and they encourage a sense of play or feeling rather than attention to composition.

Sometimes there is a break or edge in the texture, revealing an inner structure and providing a focal point. You have to cultivate a more emotional connection, using that same part of the brain that appreciates music. Instilling an emotional response in viewers won't happen unless you first experience an emotional response to the scene before you.

In texture there are tessellations, multiple junctions, wrinkles, cracks, ripples, myriad small lines, waves, curves, circles, and polygons. You'll be struck by the intricacy of anything you look at intently. It is an exhilarating experience to view any natural surface or landscape from coastline, to fern, to bacterial growth and recognize that, far from being merely patterned, it is made up of many individual shapes, each with its own surface also intricately patterned with shapes . . . and on and on. You repeatedly see the same elements or shapes at different scales or magnifications, which reveals an underlying geometric regularity, a self-similarity. A recent mathematical study called *fractals* has discovered formulas that describe this infinity of repeated regularity. According to John Briggs,

a leading writer on fractals and art, "We see fractals every day. Trees, mountains, the scattering of autumn leaves in the backyard. . . . Fractals describe the roughness of the world, its energy, its dynamical changes and transformations. Fractals are images of the way things fold and unfold, feeding back into each other and themselves." On the following pages you'll explore more patterns and textures that are fractal, the result of a self-organizing order out of seeming randomness.

In the dark Patagonian forest, I used a flash off-camera to the left to provide edge lighting and bring out the texture of each leaflet of this fern. The fractal growth pattern is also in sharp focus.

Watching for textures enables you to zero in on patterns that are inside typical boundaries. Shooting with a 300mm lens, I tightly framed the backs of these zoo tapirs to emphasize the velvet texture and make a composition with the two fallen leaves.

Growth and Branching

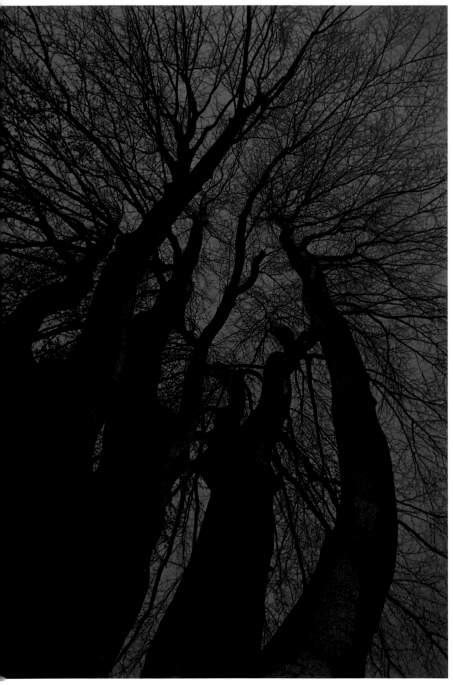

Lying down at the base of a copper beech tree, I used a 28mm lens to frame it soaring above me. The blue springtime dusk and the tree's bare limbs accentuate the raw power of growth that the picture conveys.

Trees are among the most striking objects in nature. They are the largest, tallest, heaviest, and oldest living things ever to inhabit the earth. Their growth pattern covers a lot of space and distributes energy easily. Branches sprout from the previous year's growth according to the genetic pattern of the species, but then bend and twist to adapt to each tree's particular exterior environment. This natural pattern of growth places each of the tree's leaves in an open position where it can receive the greatest amount of sunlight.

This branching process of gathering and/or dispersing energy between a center and an outer periphery is seen in both huge and minuscule natural systems: rivers, lightning bolts, crystal growth, neurons, roots, leaf veining, blood vessels, bronchial networks, bacteria growth in a petrie dish, and erosion patterns.

Each of these systems is a network of distribution, flux, and growth that, when analyzed, consists of geometric pieces of similar shape but diminishing size. Non-living dendridical patterns in crystals and stream networks grow at the tips because energy there is higher, and more attractive to tiny particles being added or eroded. In plants and animals, common evolution dictates that these networks resemble each other across all sizes and types of creatures because they all branch down to reach the cells, which are approximately the same size in all organisms. Ultimately the cell shape and arrangement give pattern to the network. Most branching patterns are self-similar at any scale—in other words, fractal.

Benoit Mandelbrot, an IBM mathematician, invented a new geometry based on a formula that employs types of feedback of the results back into the next equation. He saw in this an analogue of these natural patterns, and a way to describe and study them. In 1975 he coined the name *fractal*, meaning fragmented, to describe the geometry. Some of the patterns drawn by computers following the mathematical results look like the growth patterns of trees. Others duplicate the kind of complex space-covering curve that native weavers and artists all over the

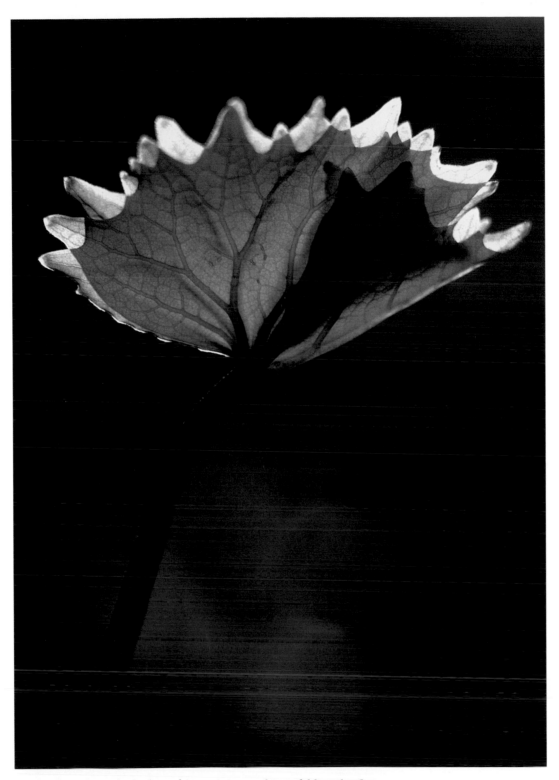

Backlighting brought the branching veining in this unfolding deerfoot leaf, barely an inch wide, into clear focus. A wide-open aperture on my 55mm lens threw the background out of focus, which draws even more attention to the delicate play of light and shadow in the life size subject.

world have applied in their designs and mandalas. The patterns also simulate the infinite repetitions of jagged promontories on precipitous coastlines, and of billowing turbulence in clouds and water. The study of these equations has lead to new insights into networks, flow, weather, and the fine structure of the human circulatory system.

Fractal geometry has underscored the metaphorical and natural connections between branching and manmade systems, such as transportation, communications networks, the search for knowledge, and even the mind itself in its role as a flowing network of growing ideas. When you photograph these branching patterns of growth, your point of view is important for documenting the passage of time. Try to emphasize the similarities among the branching elements by finding the angle and light that best define the shape of your subject. For example, suppose you're

photographing trees. Walk around and under them, if possible, to explore a variety of ways to look at them. For a fresh perspective, use a telephoto lens to tightly crop the branch patterns, or use a wide-angle lens to create a view from beneath the tree looking up at soaring, curving cylindrical forms. A dark tree with a dark background can be turned into a dramatic image when late-afternoon sunlight illuminates the wet bark after a rain. At another time of year, when snow piles up on every limb and twig, the tree becomes a study in contrast and pattern. Obviously, the skeletal pattern of deciduous tree growth is best revealed in winter when the tree is bare. There will be special moments, though, such as in early spring's first blush, when the branch growth shows through a backlit, Impressionist glow of green, or in fall when the richly hued canopy of leaves fall gradually, showing more and more of the substructure.

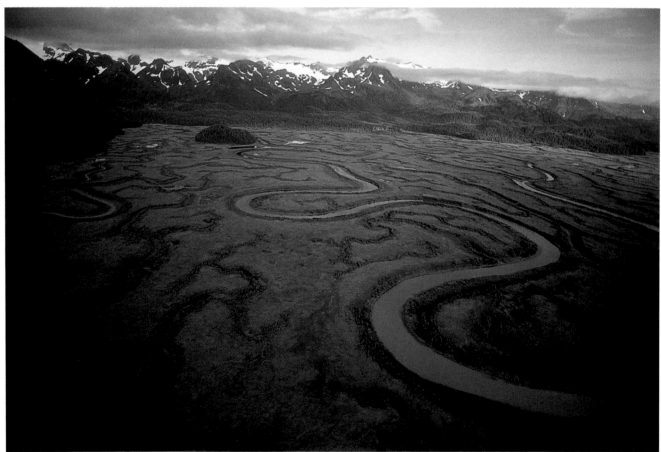

From the air, the interconnecting, meandering, branching sloughs of the Copper River Delta in Alaska resemble a kind of natural circuit board, transmitting and transforming energy from mountain and forest to the sea.

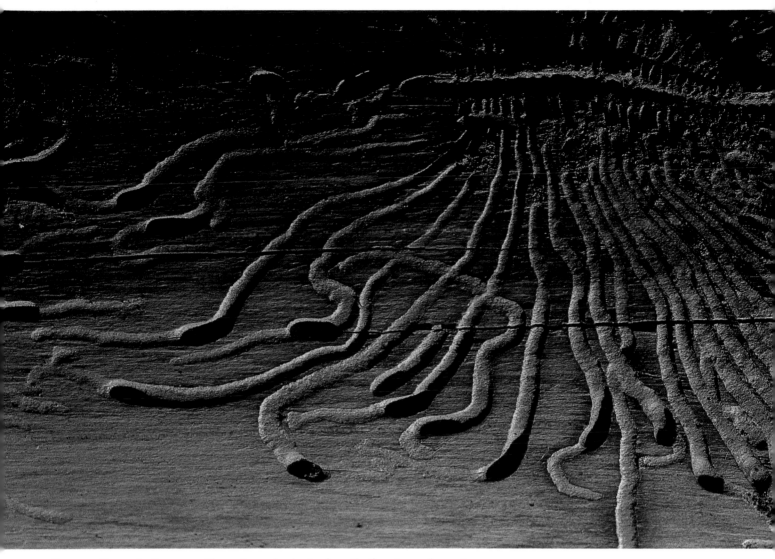

On a smaller scale, these wood borer tunnels also perform the functions of carrying energy across a space and expanding to accommodate growth. They result when larvae, hatching from eggs laid under the bark of a cedar, chew outward until they mature.

Miniature branching patterns are also found in abundance on trees. You don't need a lot of luck or good timing to find these wonderful smaller patterns, simply a mental and visual change of focus. Every leaf, like the tree it comes from, has a particular pattern of growth that you can isolate in a photograph by careful framing and composition.

Leaf shapes grow from purpose and habitat. Needles of redwood and Sitka spruce comb moisture from summer fogs; tropical leaves frequently have long drip tips to shed rain; aspen and cottonwood leaf petioles are flexible in one direction, enabling fluttering in the winds of open landscapes. Leaves with broad bases and long stems, like those of the maple and tulip trees, can roll up into cones in high winds, reducing the drag on the tree in a storm. But leaves behave very differently when they break from the tree in fall and flutter to the ground. They encounter the resistance of the atmosphere and spin and tumble in complex, unpredictable patterns. Eddies of air curl off their edges as they fall, creating a chain of vortices in the air. In this the branching fractal patterns meet those created from turbulence and chaos.

Flow and Turbulence

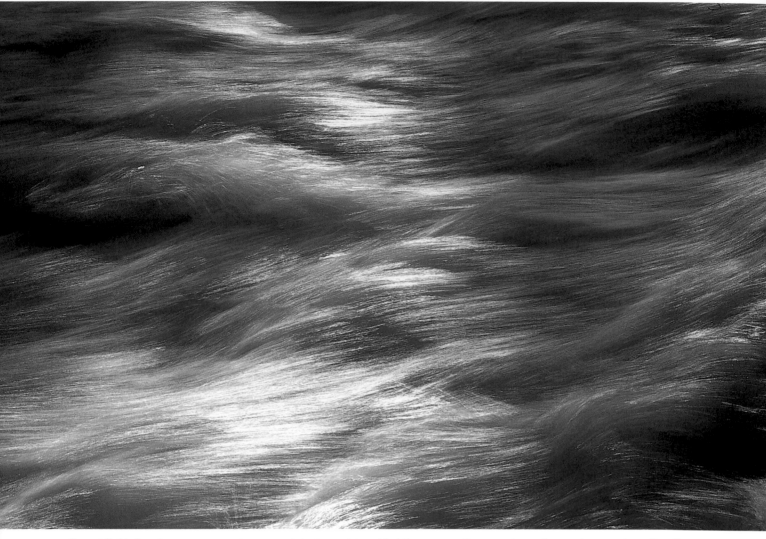

Sunset light dancing across a raging mountain torrent provided the raw material for this photograph, which I made with a 105mm lens. I exposed Fuji Velvia for about 2 seconds, extending the shutter time via the use of a neutral-density filter, to create a portrait of the stream's rounding and smoothing effects on the rocks beneath.

Our entire planet is continually flowing, from the imperceptible oozing of metamorphic rock deep beneath the earth's surface, to the rushing air of the atmosphere. The patterns that result from these motions are all around you. Like simple wave patterns that fluid motion creates, they relate visually and symbolically to each other, and they serve as reminders of the unity and beauty of motion. But what's missing from simpler images of flow is a sense of the scale and time over which motion occurs. Over thousands of years, flowing water carves rolling curves into the bedrock of a stream, and immense flows of glacier meltwater have left huge patterns of ripples, sandbars, and dry waterfalls across western America.

The results of flow over time are revealed in smooth curves when you photograph a field of windblown wildflowers or the rapids of a mountain river at slow shutter speeds. Taking exposure and shutter-speed readings of moving subjects involves an element of chance, but it isn't difficult and provides great possibilities for magical images. Study the motion of trees or grasses in the wind, a stream, the ocean surf, or even a fast-moving fog creeping up a ridge. Set up your camera on a tripod, and aim your lens at an interesting part within the composition of motion, such as a place where wave after wave crests, the contrasting still point of a rock, or among grasses stirring in a wind. Take a moment to consider the existing light and exposure conditions. If the light is very bright, exposures of 1/15 sec. or 1/8 sec. might be the longest possible, even if you're photographing with film as slow as ISO 25 or ISO 50 and using the smallest aperture on your lens. These shutter speeds are still long enough to smooth the motion of waterfalls, rapids, and other extremely fast fluid subjects.

You can extend the exposure time under bright conditions several ways. A polarizing filter, which is also called a *polarizer*, adds about two stops and thus lengthens shutter speeds to about 1/4 sec. or 1/2 sec. A 0.9 neutral-density (ND) filter adds three stops of exposure and a corresponding increase in shutter speed. At 1/4 sec. to 1 sec. exposures, such subjects as waves and windblown leaves blur on film, revealing rhythmic patterns. If the light is low, exposing at small apertures can lengthen shutter speeds to whole minutes. Grandly swaying trees and fallen leaves floating in brooks create beautiful, surprising patterns of motion with long exposures. But keeping the shutter open long enough can lead to unexpected problems, including camera vibration and reciprocity failure. With very long exposures, films often take on a greenish or magenta color cast, or produce a darker exposure than you wanted. A good way to learn about this is to always take notes of the different exposure, speed, and lighting conditions you encounter with various subjects.

These pictures, shot in New Hampshire's White Mountains, demonstrate a common use of motion in photography: to personify the wind. I exposed the top image for 1/250 sec., which was fast enough to freeze all motion. In an attempt to put more feeling into the rich lines, colors, and textures of these oaks and birches, I then exposed the bottom image for several seconds through a stopped-down 105mm lens. I used a cable release during a heavy gust to capture the greatest movement on film.

The smooth flow pattern begins to break up when energy in the system pushes the waves and eddies into faster, deeper, and tighter curls of movement, and they begin to tumble into each other. Like a smooth stream surface merging into a steep, rocky rapid, the flow pattern becomes a maelstrom of churning turbulence. Turbulence, an archetype of chaotic motion, can be seen in the surface of a bubble (which is thinner than a human hair), the growth rings of a tree, clouds in the earth's atmosphere, the storms of Jupiter, and nebula of the universe.

Once again, new theories in mathematics, including fractal geometry, have opened vistas of understanding about these events that seem random or unpredictable but are nevertheless governed by some set of rules.

Turbulence is a sign of disequilibrium. You see it whenever an unstable boundary between opposing or evolving forces becomes visible. This is the place where

The bark of an ancient Western red cedar looks as turbulent as any wild river, but the tree's time scale for movement is much slower—about 400 years. This portion, photographed with a 105mm lens, tells something of the tree's age, weight, bulk, and efforts to survive.

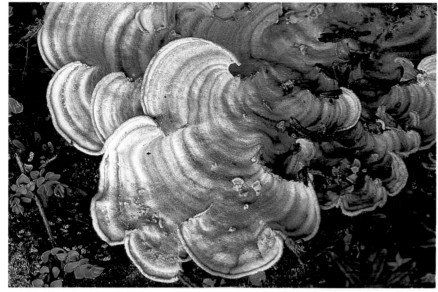

A tiny Costa Rican shelf fungus, no larger than a silver dollar, shows the same patterns of billowing growth exhibited by cumulus clouds.

The sand-dune genesis of Canyon de Chelley's walls in Arizona is revealed in its exposed shapes and cross bedding. The trees provide a necessary sense of scale in this 300mm view, which I shot from an overlook; otherwise, you might think you were looking at a patch of sand on the beach.

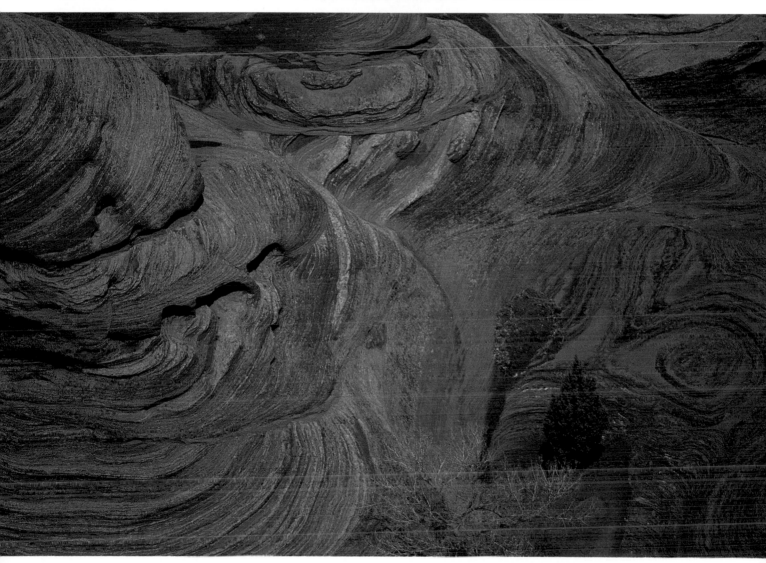

solids melt, gasses condense, leaves sprout, and fluids begin to mix. The boundary moves and as it does it wrinkles. Parts of it pull ahead or are retarded. Bulges attract more energy or collect more on the surface and bulge even more, creating folds within folds, and spikes of intensity alternate with deep quietude across every time scale. Stable shapes form and are washed away. Still, over long time spans the repeated traces of randomness etch a shape, which mathematicians refer to as a "strange attractor" that shows the organized boundary of the system.

Besides the common but irresistible turbulence of storm clouds and rapids, chaos happens slowly, too, as when a flower's growth continues while its petals are still enclosed inside the bud. Some trees have flowing and turbulent growth patterns that precisely mimic those of water patterns. The wood doesn't actually flow; instead, as the trees adjust each year to changes in the weather, encroachment, and new injuries, their growth rings diagram these changes. The stresses are apparently distributed in a fluid manner, like the lines of magnetic force around a magnet, and the new wood grows thickest along these lines of stress.

You can see examples of layering and turbulence across various scales everywhere. I found intricate patterns created by pollen and road dust on a coastal plain on Tundra Lake, near Kaktovik, Alaska (top), and complexly deformed, cross-bedded, and veined metamorphic rock in Maine at Marshall Point (bottom).

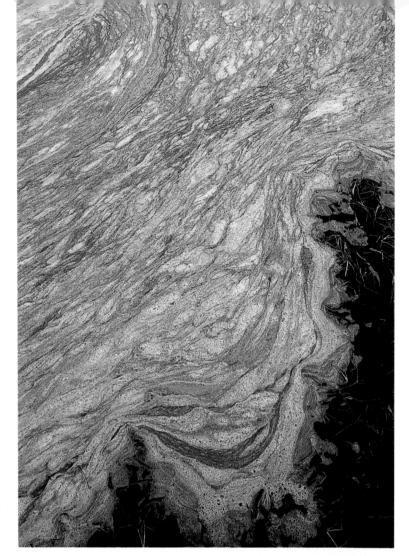

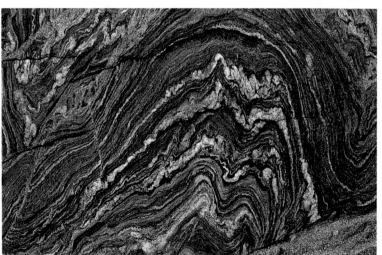

Weather Patterns

Growth, flow, and turbulence are continually played out above you in an ever-changing canopy of patterns. Quite apart from the very spectacular displays of refraction and diffraction (see pages 70–73), the daily sky is an incredible palette for the interactive elements of flowing air, water vapor, ice particles, dust, and the sun. It is important for photographers interested in patterns to keep an eye on the weather and learn something about meteorology. You should understand how clouds are generated by advancing weather and change depending on the time of day and the color of the light.

One technique is to study the daily weather maps and compare them with what the skies in your area actually look like. This will help you learn to anticipate potentially great shooting conditions. Also, you can listen to the National Oceanographic Atmospheric Association (NOAA) radio weather forecasts and carry a tiny radio tuned to these special stations across the United States. Books about weather, such as *A Field Guide to the Atmosphere* (Houghton Mifflin, 1981), are also excellent references. And you should especially make a habit of looking up and westward (or toward whatever direction your weather usually comes from). I've learned that storms approaching my home are often heralded by great plumes of cirrus clouds and layers of ice crystals that often result in circles around the sun. When a storm is over, I watch for patterns of sudden clearing over the ocean when the sunlight can stream under the remaining coastal clouds, illuminating first one layer and then another in a continually changing drama of color and shape.

Photographs of lightning strikes are one of the holy grails of outdoor photography. Those who live or travel in "Tornado Alley" in the Midwest, the desert Southwest, or Florida have the most chances of capturing these phenomena on film. Strong electrical potential builds between negative clouds and positive ground or between clouds during a storm, apparently when water particles begin to freeze and fall and rise at different rates in the shear of high winds. The stroke itself can deliver more than 100,000 amperes in microseconds. Fortunately there is some warning of an impending strike. So in the exhilaration of watching an approaching thunderstorm, be very alert to the proximity of lightning and a buildup of charges that can literally stand your hair on end. Try to shoot from protected locations or from out of the storm's path, and remember that tripods are great lightning rods!

Making the picture is technically simple: Aim your camera and tripod directly at the ongoing thunderstorm. Get to the location before dark, if possible, in order to both familiarize yourself with the landscape and to catch a little waning light in the surrounding clouds. The lightning will often produce enough light to illuminate the surrounding clouds and horizon; be sure to use a wide enough lens to include everything in the frame. Choose a medium-wide aperture for medium-speed film, and then set the "B" (bulb) shutter-speed setting on the camera (or an arbitrary, very long exposure time). Use a lockable cable release to trip the shutter. Keep the shutter open through any spectacular series of lightning bolts.

If the horizon in your photograph is crooked because you couldn't see it in the dark, buy an inexpensive camera level. Caught without a tripod? Use a car hood, flat rock, trashcan, or post. No cable release? I've sometimes used tape and small rocks to hold down the shutter button. But as cameras get more electronic, there is a good chance that your camera shutter will just stay open on an automatic setting, given the darkness. Experiment with your particular camera model.

Photographing the sky and clouds is simple compared to photographing during conditions of actual precipitation. Trying to shoot in heavy rain, wet snow, and wind is extremely difficult because you, and all your equipment, are going to get wet. Most modern electronic cameras don't withstand direct flows of water as well as the older mechanical cameras did, but they are remarkably resistant if wiped off frequently. One solution to working in constant downpours or near waterfalls and surf is to use an underwater camera or an all-weather camera. In conditions of light rain, snow, or mist, or on

hiking trips through humid rain forests, good rainwear protects you. If it is really hot, I don't mind getting wet, keeping the rain off my head and face with a fisherman's hat that is always in my camera bag. I protect my camera by keeping it in a heavy plastic bag, such as a large zip-lock or freezer bag (produce bags are too flimsy); I simply put it on and take it off as I set up each shot.

Always check the lens just before each shot, and clear off any large water droplets or condensation that will otherwise show up on your slide or print as smudges. A supply of very soft cotton handkerchiefs works best for

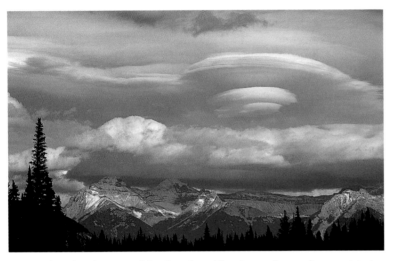

Lenticular clouds, named for their lens-like shape, form when moist air moves over a mountain into cool air. This leads to clouds that reveal the flowing waves that result. Here, a series of waves hangs over Banff National Park in the Canadian Rockies.

Clearing rain on the Arctic Ocean provided the tiny water drops for this rainbow and its stunning multiples. The low midnight sun's reflection off the glassy water creates the unusual vertical rainbow that crosses the direct refraction bow and its double.

wiping water off your camera, but be extremely gentle when using a hankie on your lens. In conditions of high wind or blowing mist, since you'll be continually wiping the glass, use a clear glass or skylight filter. Find a sheltered spot where you can change lenses or film, or lean over your gear so that any excess water on your rain hat runs off harmlessly. Be very careful if you need to gently wipe off any drops that get on the rear lens element or inside the camera.

In sub-freezing conditions condensation might freeze on your lens if you breathe on it. Photographers who wear glasses are already intimately familiar with the inconvenience of condensation. The greatest danger occurs when you bring cold cameras inside because condensation might form even inside the lens and on surfaces within the camera body. If exposed to cold again, these droplets may freeze. If you're photographing for many days in a cold climate, it is a good idea to try to keep your gear at as constant a cold temperature as possible. If you must bring your equipment inside, minimize the effects of condensation by first putting your camera inside a plastic bag or camera case with silica gel cartridges. While shooting in the cold, keep warm batteries in your pocket to replace those that lose power fast when inside a cold but electricity hungry camera. Remember, autofocus and high-speed winders require lots of power and might need extra care in extreme cold. Above all, keep yourself warm by eating and drinking enough and wearing sufficient clothing, especially warm gloves and a good head covering (most heat loss occurs through the head). Protect your fingertips and nose from freezing to the cold metal of your gear.

Surviving bad weather physically leaves you free to make pictures, but you must also overcome weather conditions in terms of the effects on light and exposure. Brightly lit snow, for example, is extremely dazzling to both your eye and exposure meter. The meter, calibrated to measure subjects of normal intensity, might give an incorrect exposure under bright snow conditions, which will result in gray snow and underexposed subjects in your photographs. To expose correctly in these conditions you must overex-

pose by two or more stops beyond what the meter reads. You can work the other way, too, by metering directly on the object in the snow and then ignoring your meter's wild swings or pushing "exposure lock" when you recompose to include the snow. Photographing snow in shade, at twilight, and down deep crevasses means coping with a strong blue cast from the sky; this can be partially corrected by using an 81-series filter.

Shooting in fog and mist has exposure pitfalls similar to shooting in bright snow conditions because extra ambient light is everywhere; therefore, you tend to underexpose your subjects. Fog diminishes color and reduces objects to mere silhouettes, and underexposing can be used creatively to evoke a sense of mystery. Intentionally overexposing in fog also yields dramatic images that emphasize the sun's rays as they break through tree branches. The larger the water particles present in the air, the less colors are obscured. Cloud droplets are about 10-20 micrometers in diameter; rain grows into the 4 millimeter range. In rain or snowfall you can expose under normal or average meter readings.

But rain and snow, which are brighter than most other subjects, will appear as white dots or streaks on the film if your exposure time is longer than 1/8 sec. The greater the depth of field, the more raindrops will be in focus. Take extra shots when huge raindrops or snowflakes are falling since those closest to the lens can make annoying out-of-focus white blobs, especially when illuminated by sun or your flash (use off-camera flash).

Iridescent cloud formations are a striking effect caused by the diffraction of sunlight by tiny water droplets in a thin cloud. These are rare in inland areas but more common near mountains and coasts. The colors this effect produces vary according to the size of the water particles. With a perfect combination of cloud thinness and particle size, you might be able to shoot directly into the sun while it is diffused by the cloud, revealing beautiful shifting bands of color all around it.

Being in the clouds is another great way to photograph weather patterns. Incredible vistas across the tops of fogbanks and the rolling high shapes of cumulonimbus clouds

are visible from the windows of airliners. Whenever I fly, I request a window seat away from the wing area. My loaded camera and 50mm and 105mm lenses are always ready, and I stay alert—especially during dawn and sunset hours or when I think thunderstorms are building along the flight path. Even though the thick, scratched airliner windows prevent making sharp aerial pictures of the huge geologic patterns on the ground, they don't pose a problem for cloud photography; just work close to the window to minimize reflections and scratches showing up on your images.

Focusing a little in front of the trees to record an uninterrupted plane of falling snow, I used a relatively fast shutter speed to stop these flakes in midair.

The Three Graces, a group of sea stacks on the Oregon coast, are the stage for an Asian-looking landscape composition, which I shot with a 105mm lens one foggy afternoon. The fog renders the human figures, dwarfed in comparison with the pinnacle tree, even less important and anonymous.

Approaching storms are more threatening than clearing weather, but the increasing intensity is powerful. On a workshop field trip in New Mexico, my class witnessed the rising sun blasting orange light on the volcanic rocks and turning low clouds iridescent.

It pays to go out to see the sunrise and sunset every day you can. Momentary effects are unpredictable, storms clear at the last moment, and clouds change rapidly. On the Oregon Coast near my home, a gray day broke at the last minute into this etched mackerel sky.

DOCUMENTING MOTION AND GROWTH

The patterns explored so far were all created by continual processes of growth, flow, and evolution, but the photographic emphasis has been on recording a still subject. Making photographs that directly communicate and document the world's continual motion is a special challenge. The patterns covered next directly address this problem of recording movement and growth. Perceiving and recording the way objects change over time is something photographers do naturally as they watch the changing light at dawn or wait patiently for the tide to ebb.

One exercise that can increase your awareness of changes over time is to make suites of pictures of the same scene taken at different times of the day or year: for example, a single tree photographed at first light, noon, dusk, and evening. You probably already possess such a series. Look in your family album for the portrait "landscapes" of family members' faces as they change through the years. You might have used a fixed-camera position in front of your growing child or the annual family picnic group, and let the passing years develop a sequence on film. While the results of a fixed view of a landscape are less likely to evoke such intense feelings as family portraits, images of nature photographed over time foster an awareness of the cycle of days and seasons. It is actually easy to capture the passing of an entire day. You simply place a tripod at a selected viewpoint and return to it at different times: dawn, sunset, when grand clouds gather, or when the sunlight accentuates certain textures. Recording the seasons takes more planning, such as remembering your fixed-camera position and marking it carefully so that you can always return to it accurately. You might make a duplicate slide or small print as a reminder of framing and composition.

Becoming more attuned to the rhythmic changes of motion and growth in the world can help you recognize the many individual designs that literally document plant and animal responses to these same cycles of growth. Every single moving thing on earth, whether it is the 200-miles-per-hour jet stream or a 200-year-old oak tree, reacts to the same natural forces and immutable laws of physics. The patterns made by their motion, flow, and growth over time are remarkable subjects for nature photography.

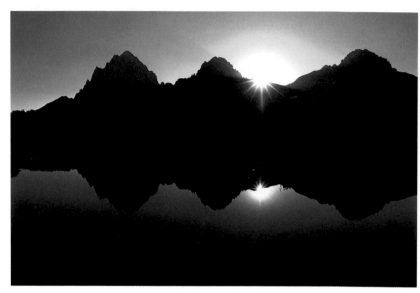

The course of a day is revealed in Schoolhouse Basin behind the Grand Teton Mountains in Wyoming. I used a 105mm lens and a tripod to capture, from left to right, sunrise, late afternoon, and sunset as played out beyond the shores of the same tarn.

Three seasons pass through a line of Lombardy poplar trees that grew behind my old house. From left to right you see summer, autumn, and winter. The flock of birds flying across winter's dull sky injected some needed interest.

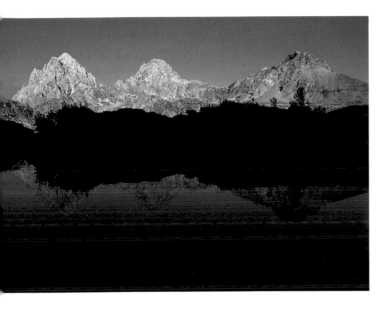

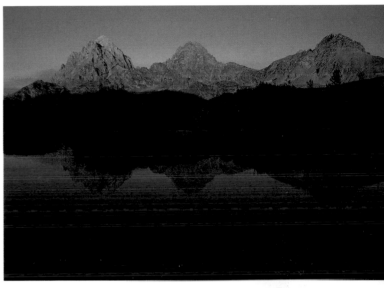

Animals and Biodiversity

Animals are part of the landscape. Their very survival is dependent on their shapes, colors, senses, and movements that co-evolved with the habitat. Animals give life to the land just as they've taken life from it. They are frequently difficult to photograph, but the patterns of their lives offer rich, creative possibilities.

Few photographers will ever become professional wildlife specialists, with all the expensive lenses, travel, and time that occupation requires. Also, successful wildlife photography demands an extensive knowledge of animals and birds, a tolerance for the physical punishment that comes with reaching and stalking them, and the patience to sit in blinds day after day waiting for events that might not happen.

For most pros, a minimum telephoto lens is a 400mm, though 600mm and 800mm "cannons" are common choices when distance is inevitable or necessary for safety. These huge, and hugely expensive, lenses also increase the possibilities of getting portraits. If you can't get close enough to animals for portraits, which is very common, expand your view into the surrounding landscape. Compose images that document the animals' movements, behavior, or ecology. In Africa, for example, a seemingly endless herd of wildebeests and the way many species congregate around waterholes can reflect the great number of creatures that inhabit that continent. If the wildebeests are in flight, panning for 1/8 sec. to 1/2 sec. will blur the motion of pounding hooves but will preserve the animals' distinctive body shapes.

Silhouettes are also exciting symbolic renditions of animals. Many photographers have

The caribou of Alaska's arctic coast migrate farther than any other land animal, and despite their huge population, which numbers in the hundreds of thousands, they are difficult to locate in the vast wilderness of the Arctic Wildlife Refuge. When I had the luck to witness a river crossing, I used a 300mm lens and panned with the animals to convey their energy and wild nature.

returned from photo tours of the African Serengeti with simple, yet powerful—and salable—images of the horizon at sunset, acacia trees, and giraffes in silhouette.

In the last 10 years or so, the creative and out-on-the-edge work of photographers like Frans Lanting, Michio Hoshino, Tom Mangelson, and Michael Nichols has expanded the range of wildlife photography. They have shot at night, in all types of weather, and at extremely close range, and have taken advantage of technical advances in lenses, panoramic cameras, and remote controls to make images that seemed impossible.

Photographers seeking to emulate these pros must keep in mind the extreme physical sacrifice, time, and money expended in this work, and that it usually relies on long-term professional contacts in parks and reserves. There is also danger. A brown bear in Kamchatka fatally attacked Michio Hoshino, who was revered for his spiritual connection to wild animals of the north.

Most of the shoots these photographers are known for were made during assignments for magazines like *National Geographic* or supported by strong marketing and sales. The photographs are powerful illustrations for magazine articles and in campaigns by environmental groups about the goals of conservation and the results of increasingly detailed scientific studies. But these very studies are showing that most larger animal and bird species—the earth's "charismatic megafauna," as some call them—are losing ground to encroaching civilization. The time is probably past when it was possible to casually enter a wild area and be assured of seeing and photographing the larger creatures. In fact, the very presence of a human might change the behavior of a grizzly or a nesting bird colony enough to disrupt breeding success. Disturbed animals might be more likely to attack.

Photographers who want to see large animals on short trips can do so on safari tours, at lodges near Amazonian wildlife concentrations, from protected view spots on rivers where bears feed on salmon, aboard Antarctic cruise ships, and under the direction of experienced bush pilots and guides.

I advise all would-be independent wildlife photographers to become students of the animals and their habitats, and to make detailed plans with the advice and consent of wildlife managers and researchers. There is a great need for images of undisturbed animal and bird behavior that can contribute to our knowledge and ability to protect our fellow creatures.

What we might not need is more straight, close portraits of animals just standing there.

Lubber grasshoppers hatch in tremendous numbers some years, and since they apparently taste terrible to potential predators, they remain plentiful. During an assignment in the Florida Everglades, I watched them pass through three instars to bright yellow adulthood. In the second instar, they lined up on sawgrass.

On my two-week Everglades assignment for Life *magazine, I recorded as much of the ecosystem as possible. This large gator woke up while I was photographing him and lumbered toward me. Even though I knew he was just trying to get away, it took strong concentration to keep shooting as he splashed into the slough I was standing in.*

It takes luck, as well as planning, persistence, and skill, to get great wild animal photographs. I obtained government permits in order to enter the rookery of these endangered wood storks, brought equipment in on a kayak, and built a blind near one of the few accessible nests. I still needed great luck to get a nest with two babies and birds that interacted so beautifully.

Or jumping directly at you. Or bears standing up and growling. Or Siberian tigers running in surf. The images do sell: they are a cliché of calendars and advertising because of their symbolic value. But the majority of these tight, perfect shots are not normal behavior and are made not in the wild but at zoos, game farms, and Hollywood rent-a-creature menageries. This is not a problem in terms of the photography, especially since it is a pleasure to view great animals and to make good photographs of them. Zoos and research centers are usually involved in conservation work and might provide the only opportunity to photograph certain rare species. However, some commercial game farms are reported to keep their animals in tiny or inhumane enclosures, and nature photographers should discourage this by staying away or reporting poor conditions to state authorities.

One issue that has raised ethical questions and made photographers argue with one another is how the photographs are captioned. Some photographers fail to reveal the location and that the animal was captive. Another controversial issue is the use of Adobe Photoshop to remove or add elements in a zoo image, thereby making it appear to have been shot in a natural habitat. The North American Nature Photography Association (NANPA) issued a policy statement about "Truth in Captioning," emphasizing that in editorial and documentary use,

photographs "are assumed by the public to be straightforward records of what the photographer captured on film. . . . Creators of images should be truthful in representing their work." NANPA suggested photographers adopt short code words that identify the image as "wild," "captive," "photo illustration," etc. This enables an editor to use a great zoo shot or manipulated image as a textbook illustration or an advertisement, but not for a story about a wild habitat. (For more about ethical issues, see Part Three.)

Clearly, there is a great deal of emphasis on visiting famous exotic places and making perfect images of the beauty of nature. In my view, though, there is a lot of adventure and perfection much closer to home, and closer to nature. I find my models in photographers like Carl Sams, Wendy Shattil, and Bob Rosinski, who are so dedicated to long-term documentation of "ordinary" places near where they live. I'm inspired by scientists who often deeply investigate individual subjects and work out the interrelationships among them.

A new blossoming of ecological knowledge, a recognition of the way habitats work, and a celebration of the biodiversity created in and supported by them are taking place. We're reminded that every place is a habitat; we each live in one of them! These ecozones, macro patterns of nature, don't stop at park or state boundaries, and each of them has unique animals and plants. Non-famous places like scrublands, Southeastern pine forests, and high deserts often have great diversity, much of which isn't protected in parks and refuges.

In my career an early example of interdisciplinary science in the ancient temperate forests inspired me. In the 1990s I went on to develop stories of individual places, recording ecosystems in depth in tide pools, the tropics, the Everglades, and the Arctic. I consider it my highest aspiration and the most creative and challenging work I do. I found incredible adventure in the deep exploration of individual landscapes. This approach integrates the big scenes and large animal shots, with all the supporting elements that make up the habitat. I developed a range of skills encompassing every lens and accessory, every time of day, and every viewpoint from aerial to underwater.

In a typical shoot I'll employ wide-angle land-scapes, blinds or stands for specific animals, and macro and flash work. I use my knowledge of patterns and growth to get the insects, plant details, and the smaller relationships that often turn out to be crucial in the ecology of a place. So many behaviors, activities, natural events, and environmental stories usually go unrecorded.

The technique of becoming a "resident" in one habitat is useful for any nature photographer. It slows you down, opens your eyes and mind, and makes you a more integral part of the landscape. You see and understand more. More animals and events make themselves visible. A return to the child like unity with nature draws many people to nature photography.

You don't have to travel far to find your subjects; gentle and fearsome animals are everywhere, in all sizes. Whether you're photographing a buck or an eagle at a refuge, or a jumping spider or a praying mantis seen through a macro lens, all are excellent subjects found much closer to home. Wherever there are plants, there are animals; even apartment dwellers can increase their sightings by planting window boxes with bright flowers to attract butterflies and by hanging bird feeders. Many professional nature photographers maintain natural gardens expressly for the insects and birds they become home to. Some pros keep their cameras continually pointed out windows at bird feeders to capture not only bird portraits, but also images of fluttering wings or flocks settling into bushes. And with closer attention to and deeper knowledge of the animals you photograph, will come an increased appreciation of their design, coloration, and growth.

Like all essential elements of nature, animals have always been part of the human experience, yet the deepest mysteries of their lives remain. This is why animal symbolism abounds in every culture and religion, and continues in our commercial-advertising culture. In my work, I value images of animals in the landscape, in motion and in flight, as icons of freedom, adventure, instinct, and transcendence.

An assignment from Natural History *magazine afforded me the chance to visit the Chilean desert. After several days I worked close to this Stephanoides green-backed firecrown hummingbird, which was resting on the long spines of a Eulychnia cactus. I used a 500mm lens, extension tubes, and fill flash—and good timing to get the open bill matching the spines.*

One of the great wildlife spectacles of South America is the feeding of macaws at the clay cliffs of the Tambopata River in Peru. Apparently the birds crave the clay as an antidote to the strongly acidic fruits they eat. I photographed these red and green, blue and yellow, and scarlet macaws from the top of the cliffs.

Part Two

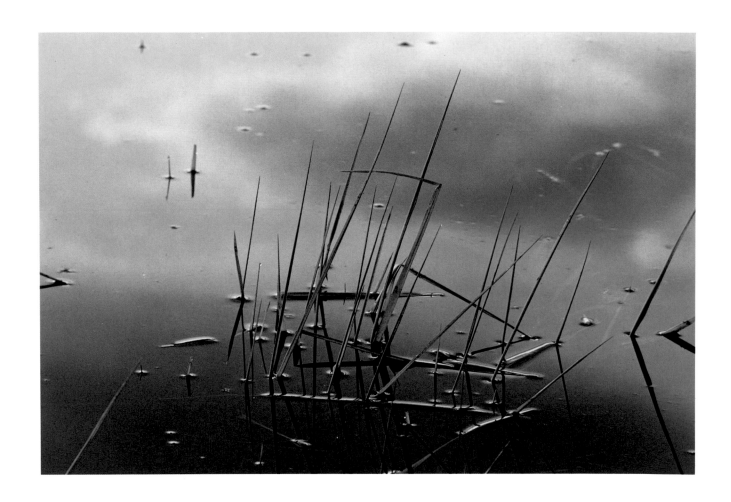

DESIGNING
AN IMAGE

MAKING THIS PHOTOGRAPH had its drawbacks. Mostly I remember the mosquitoes; they were incredible—the equal of Alaska! I struggled to hold my camera with one hand and set up my tripod with the other, meanwhile swatting my neck. The light, the beautiful light, was changing fast as I angrily rummaged in my pockets and the bottom of my daypack for some insect repellent. Nothing! Surely this, I thought as I covered the back of my neck with a handkerchief, is a nature photographer's hell: being eaten alive while the light fades. The sun's last rays were raking along the ragged underside of the cloud, illuminating one edge and then another, while the color gently changed from oranges, to pinks and purples. I didn't have much time left to photograph the incredible shapes, edges, reflections, hues, and patterns. A wonderful wide-angle image, I thought, as I loaded up with Kodachrome. . . . Look at that cloud edge, such an exquisite interplay of pink and blue. . . . That is when I saw this group of reeds in the edge of a reflection. I went right for my Nikkor 105mm lens and focused. I forgot all about the mosquitoes.

When I look at "Sedges in a Pond" today, I see the multiple contrasts in its patterns—the sharp sedges piercing the surface tension of the water while it reflects a sky full of soft clouds; the blues and pinks cut by the crisp greens of the sedges; the angles contrasting the curves; the visual illusion created by the reflections of the sedges, the water, and the sky. However, back when I made the picture, I didn't think about any of these things. I simply reacted instinctively to a powerful image. I was on a self-assignment, traveling up the Columbia River to look for scenes echoing the great wilderness landscapes that existed in 1800. I wasn't making much money then, and I felt I had to be careful not to use up too much film. My first frame was this medium shot, full of abstract qualities. After shooting a few of these, I mounted my 28mm lens to photograph the full landscape before the light changed too much. There has never been any doubt in my mind that my instinct was right. The first image's dramatic yet piercing softness has made it one of the most unforgettable photographs in my portfolio.

When you compete with other photographers for the eyes and prospective business of editors, designers, and gallery owners, having an unforgettable image is a powerful advantage. This one opened many creative and professional doors for me. Its contrasts of color, shapes, and symbols taught me I could make pictures that were abstract and real simultaneously. My only regret is that a lot more pictures that I saw in that pond got away!

THE CREATIVE PROCESS

This section of the book explores ways to combine the patterns of nature into richer and more graphic compositions. It also suggests further practice for looking at, and really seeing, the designs in nature. Knowing how to react to and photograph "Sedges in a Pond" was partly intuitive, and partly the result of my continual looking at many pictures and trying to figure out how they work. This process has helped me acquire an instinct for certain visual cues. My notes from the "Sedges" shoot include thoughts about composition and abstraction. I'd studied Asian landscape scrolls to learn about scale and atmosphere, the paintings of Georgia O'Keeffe to discover her use of abstraction and proportion, and the photographic prints of Ansel Adams to learn about light and shadow. I'd also been experimenting with reflections and would often turn a slide upside down to see how it looked that way. And I was learning new pictorial techniques by using my lenses and Kodachrome at different apertures and exposures in changing light.

Expression and experimentation are key elements in the unfolding process of seeing designs in the world. Unfortunately, the emphasis in learning photography is usually on the hardware and the mechanics. What people really care about in a photograph, and what moves them to take pictures, is subject matter, composition, and content. Today, technique is getting to be automatic, but the ability to see, think, and imagine a photographic idea is an art that must be developed.

My creative process has been influenced by such photographers as Edward Weston, Paul Strand, Paul Caponigro, Minor White, Eliot Porter, Andreas Feininger, Dennis Stock, William Garnett, and Freeman Patterson. Many others are doing wonderful work, of course, and to familiarize yourself with it, you should read photography magazines and books, look at calendars, and visit museums and galleries. The art of Impressionist and Expressionist painters, such as Jackson Pollock, is a wonderful inspiration for abstract photography, and the modern realism of Alan McGee and Robert Bateman contains incredible natural detail. Pay attention to the work of sculptors as well.

As you begin trying to convey the scale, design, and emotional weight of more complex patterns, it is crucial to remember that the eye-brain system and the camera-film system are not the same. They operate on the same optical principles because light is transmitted into them, but from then on they are entirely different. The eye and brain record feeling and reasoning; camera and film record light through chemistry. Neither lens nor film is connected to a brain the way the eye's retina is. The brain, as it receives visual information, is also getting signals about the sounds, smells, and peripheral surroundings in a scene. Also, the brain sees in three dimensions and can perceive different intensities of bright areas and shadows, as well as the size and true colors of things. The eye-brain system can read bright light that is a million times as intense as the dimmest light it can read, and it can easily perceive detail in very dark shadows.

The camera-film system has none of these advantages. It responds to only a very specific range of light levels in any one photograph, and the lens further encloses the scene in a limited frame that excludes all peripheral sights and sensations. Color film is merely a piece of plastic that is coated with somewhat light-sensitive chemicals, and its range for recording detail in shadows includes only subjects that are 100 times darker than in sunlit areas. When you photograph, you must understand these differences between the eye-brain and the camera-film system. It is the difference between imagination and automation. Despite this difference, film is the medium used to convey your message.

You should employ and practice a few basic mental tools for creative photography just as you practice with your camera, lenses, and other gear. In addition to composition (see page 90), they are: research, visualization, experimentation, analysis, and patience.

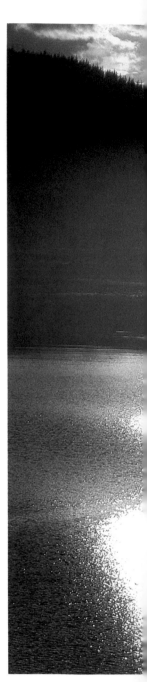

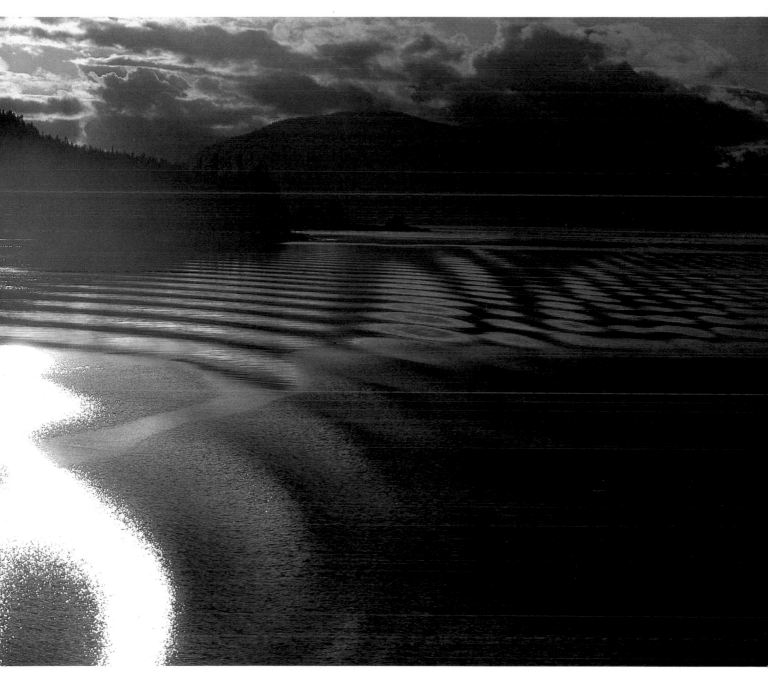

From a ferry in Sitka Strait, I shot a wide-angle view of the Alaskan shoreline. I call this image my "Henry Moore" photograph because the humanoid shape of the golden reflection reminds me of his sculpted figures.

Research

Find out as much as possible about the subject you're photographing. Come to know it fully, so that you can photograph it with a complete understanding of its meaning to you. By "subject" I mean the activity, phenomenon, or message you're trying to convey in your shot. The subject of a photograph of a rock can be the rock itself, the idea of rocks, the source of the rock, the study of rocks, or the emotions that the rock brings out in you. Read about the area where you found the rock, learn its geology and its chemical composition, and collect ideas about how it got its final shape. You might want to get across the idea of its weight, resistance to change, or smoothness or roughness. Your study might range from geologic treatises, to lighthearted books that humorously investigate why some rocks are very special to some people. This might seem like overkill—after all, the subject is just a beautiful rock! But if you convey your feeling in a beautiful photograph, I can guarantee that editors will want to know more about that rock and especially what is behind your photograph of it. It could actually be the beginning of an article, assignment, or slide show.

The ritual reading of guidebooks before a vacation should also include photography books, magazine articles, and maps. Get an idea of what subjects you'll find to photograph—how they look, the relationships among subjects, the best seasons and times of day to photograph them, and the best viewpoints and how to gain access to them. All of this preparation and note-taking will start you off with a full range of ideas to think about when you seek out your images.

Remarkable rocks often have names and local fame, such as this sea stack, located off the coast of Bandon, Oregon, called "Face Rock" for obvious reasons. I shot it at dusk with a 200mm lens.

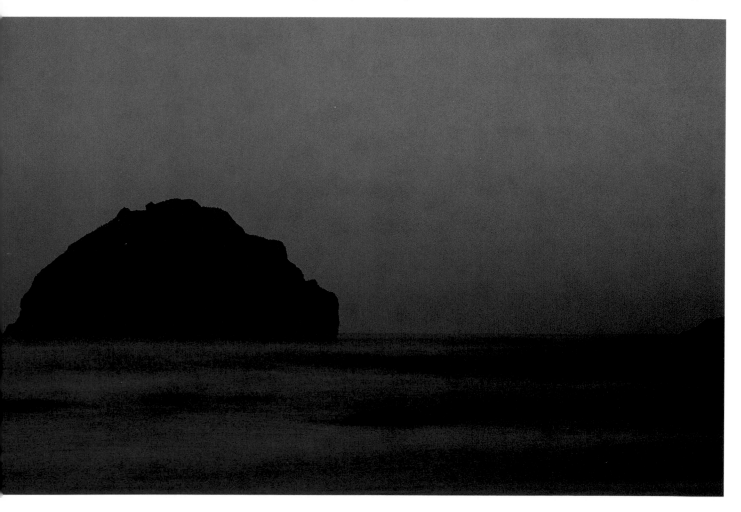

Visualization

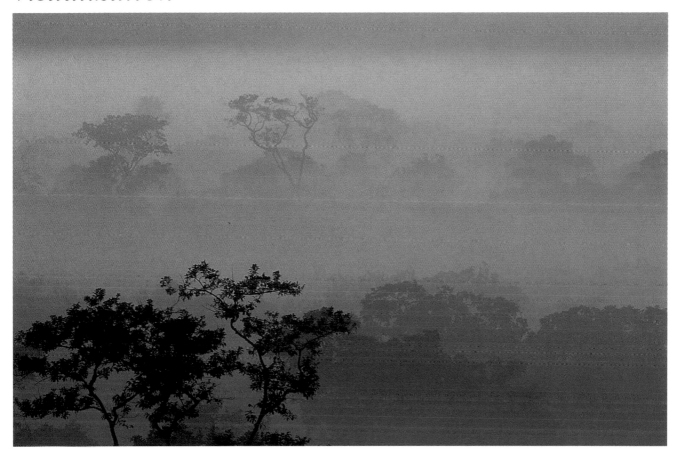

As you look into subjects that interest you, think about what is most photogenic about them and how you want to capture that essence on film. This is the process of visualization, or previsualization—a way of seeing a subject in your mind before it is actually in front of you. I find that as I learn about a place I'm traveling to or study a subject I like, I begin to imagine photographs. I rehearse them. I visualize myself there and imagine different photographic possibilities. This process helps me prepare my work with a positive attitude and thus do a better job.

Visualization can be utilized in a more practical way. For example, make a shot list of possible subjects and the ways of photographing each one: a wide-angle shot of the estuary; a vertical wide-angle shot with grasses close in the foreground; a medium shot of grasses bordering mudflats; a closeup detail of grass seeds; and a time exposure of grasses blowing in the wind. Each possibility

conjures up a vision of an actual image and often prompts you to think about what specific equipment to use or other related questions. These shot lists, committed to your notebook for frequent reference, are crucial on a planned long trip or a complex assignment. When you finally arrive at your destination, the actual landscape will unfold before you familiarly, flooding your mind with the image possibilities you've written down, and more

Visualization should be part of every photo idea that comes to you. It helps you see more of what you see now and what you expect to see next. Cultivate the ability to visualize any subject in three dimensions. For example, envision a beautiful tree from underneath its branches, from each side, at sunset and sunrise, or after an ice storm. Imagine how you would photograph ideas of "spring," or "softness," or other qualities of your subjects.

One of the most exciting moments people can experience is climbing into the tropical forest canopy to view a vast rainforest for the first time. In one of the places in Peru where this is possible, I ascended before dawn to experience the early pastel light, a moment I'd long dreamed of.

Experimentation

While you're actually making a photograph, try not to get so locked into your initial vision that you make just one shot and walk away. Experiment a little. Keep your eyes and mind open for the next picture possibility. Be alert for the unexpected. If you fail to be inquisitive and open to the world around you, you might miss something important. You finally spot that rare wildflower backlit by low sun after a rain, but that same sun could be making the best rainbow you'll ever see behind your back. Get up as planned to shoot a glorious dawn perfect for your wide-angle lens, but take your telephoto lens, too, in case mountain sheep are roaming in the distance. Never assume that only one kind of picture will happen.

Experimentation also involves varying your exposure, composition, and even your equipment. Making changes in exposure during a series of shots is called *bracketing*, a way of ensuring against exposure error or fluctuating differences in light. In the same way, I try to vary my picture's composition, moving the camera for interesting angles of view, trying horizontals and verticals, and using different focal-length lenses in the same scene. Try bracketing exposure more broadly in scenes with contrasting bright and dark areas. Watch your exposure meter as

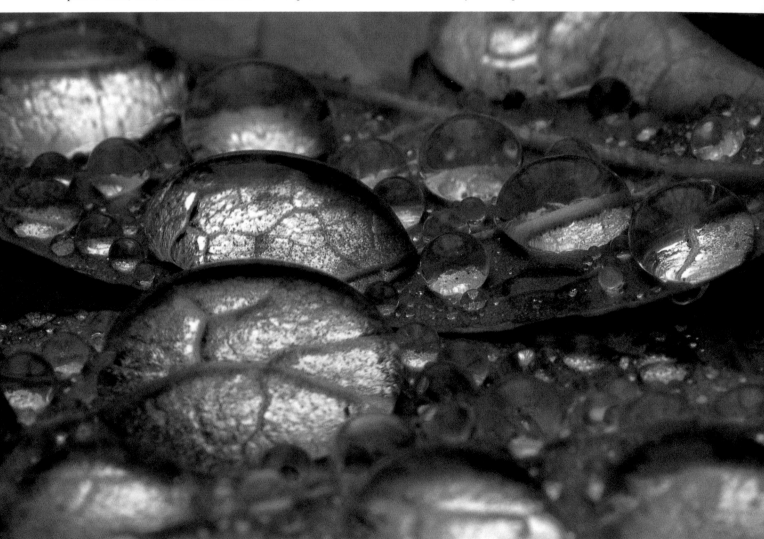

Among the synergistic developments in my work has been flash lighting, which has made closer, more detailed macro photographs possible. In this shot I followed an old interest in water drops down to the beaded surface of a maple leaf, and positioned a flash to achieve great depth of field without showing a reflection of the light.

you move the camera around the scene and see how it shifts from very intense light to shadow areas. These readings, which can have a five-or-more-stop difference in exposure (f/2.8 to f/16 with no shutter-speed change), indicate the minimum and maximum apertures for bracketing.

The very deepest underexposures work best in landscapes with strong shapes and patterns of water, hills, and sky, in which the blackened hills are silhouetted against the sky, the water ripples catch the golden light, and the brightest colors retain their fully saturated hues. This rendition creates almost an abstraction of the scene, in which most detail is obscured and near-silhouette. Deep underexposures don't work as well in images of more complex subjects, such as strongly sidelit mossy tree trunks, because the detail you need to understand the subject is lost in the black shadows. The other end of bracketing, overexposure, seems to work best in pastel-toned or shadowy scenes, such as flower closeups and foggy landscapes. Underexposing these subjects would only fill up the dark areas in the pictures with mushy grayness.

Other changes to consider trying are changes in apertures, which will change your depth of field. Experimenting with bracketing can also include varying the shutter speed to freeze or convey motion. With fast-moving subjects, try long exposures at small apertures to see the range of effects possible. Use all your lenses. Get close to your subjects in scenes with great detail, and move the camera around for new compositions. Through all this creative energy, keep in mind that film is your cheapest commodity (except for the seriously unemployed) and is much less expensive than your time and gear.

Experimentation is important because it creates unexpected images and causes mistakes. And mistakes are a sign of active work and of trying to break new ground. Even seriously stupid mistakes, like shooting with an empty camera (which I actually did at the Grand Canyon one morning), teach humility and greater care. Some of my other early mis-

takes were actually great discoveries. For example, I learned the effect of a two-stop underexposure due to a mistaken ISO setting, and that sometimes the impressionistic, soft-focus effect achieved from shooting wide open was a better choice than the "correct" deep focus. Also, I discovered a lot about all-purpose extension tubes by attaching the one made for my Nikkor 55mm lens to every other lens in my bag. In order to grow through mistakes, though, you must learn from them. I've always kept a notebook to record ideas, exposures, lens choices, and information on any new equipment or film I try. The minute I see something in a shot that wasn't supposed to be there, I want to know why it happened in order to avoid it. And if I like what happened, I want to be able to do it again.

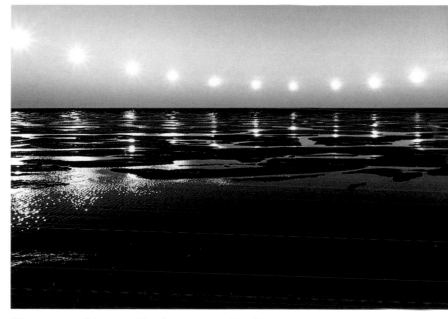

The passage of time couldn't be more graphically illustrated than by this multiple exposure of a summer sun never setting over the Arctic Ocean. During an assignment with Dennis Wiancko to photograph the tundra, one night we made exposures of this scene every 20 minutes from 9:40 P.M. until 3 A.M., using a Nikon FE2's multiple exposure feature. We aligned the camera with a compass to true north and started the sequence when the sun first appeared on the left side of the frame.

Analysis

The process of studying your photographs to see what went wrong and what went wonderfully right is analysis. The arrival of new transparencies or prints is still one of the most exciting moments for me. But the mixture of apprehension and euphoria that attends the initial quick viewing must eventually give way to a more careful inspection and ruthless editing if the photographs are to be part of a professional portfolio or permanent collection. You must hold your photographs to the highest standards of your vision, at least to the standards of the pictures with which they compete for publication. This is a difficult task of judgment and self-questioning. You might find that you need the opinion of an honest and insightful friend, spouse, or editor.

I divide my editing process into three parts. The first is a preliminary edit; after arranging all the returned slide boxes in the order I shot them, I view every slide right out of each box, using a high-quality loupe and lightbox. The Schneider Krueznach 4X loupe is the standard. Also standard is a lightbox emitting color-corrected ANSI Standard 5000K light, the equivalent of daylight.

During this first viewing, I orient all my slides right side up, and I label each box and some individual slides so that crucial caption or filing information doesn't get lost. Perhaps needless to say, the 2 x 1½-inch "Post-It" note is also a crucial tool here. Next, I check each slide for sharpness and exposure; I immediately throw out anything that is out of focus, far too dark or light, or just poorly composed. I review my shot list during this editing stage to compare what I was trying to do with what I actually got back.

The second stage of my editing procedure sometimes involves viewing each of the first-edit "keepers" on a projector. I prefer using a slide stack loader on projectors, such as Kodak's Ektagraphic and Leica's Pradulux—standard equipment in most professional studios and offices. This viewing doesn't require a big projector screen; in fact, a 3 x 3-foot white matte board on which I can project the slides from a few feet away in any small room gives the clearest, sharpest view. Some photographers have rear-projection viewing systems, but whatever you choose, the goal is to enlarge the images enough to check out the finest detail. You want to discover whether or not they convey the subjects, ideas, and emotions that you intended them to have. At this stage, if you still notice mistakes, or pictures that for some reason just don't work on a second viewing, remove them from the "keepers" pile. Under the pressure of time constraints after assignments have been completed, and with enormous shoots consisting of hundreds of rolls of film, this projecting becomes tedious. As my output has grown and deadline pressure has increased, I've tried to sharpen my loupe work so I can eliminate the projecting and get on with captioning and final selection to send to editors.

During this phase, as I consider whether I accomplished all I set out to do, I make notes about what to try next time. I notice missed opportunities. A frequent creative nemesis is failing to shoot the images that could have been simply by my changing lenses, moving in closer, shooting more vertical scenes, or bracketing enough to take advantage of dramatic light. Technical difficulties crop up whenever a new piece of equipment or a lighting effect is used for the first time, which is more frequent as camera makers battle for technological superiority. Further, analysis always introduces new ideas.

My final editing stage is to view all the "keepers" on a large light table so that I can see entire sequences of my shots together. At this stage I decide which individual shots will go to the assigning magazine, into applicable subject files, to stock agencies, and organized for editorial submission. I select the absolute best for printing, duping, and for my portfolio. I caption and number everything. Even at this final editing stage, I still discard images if they don't measure up in this side-by-side comparison with more successful frames. As you can see from this process, a valuable piece of editing gear is a large wastebasket.

To take advantage of the many ways photographs can be interpreted, a photographer has to be part technician, part librarian, part salesperson, part naturalist, part storyteller, and part child. Yes, this does take practice. I

try to look at my photographs in different environments: first, right after I take them out of the yellow or green box; with friends on a quiet evening; during a two-projector slide show to a group; scanned into a Web site or output as prints; and of course published in magazines and books. Whenever possible I encourage people to talk to me about my photographs, and I pay attention to how they're used in print. The responses of others help me learn exactly what my pictures are saying, and how well.

I've found that making simple-dissolve slide shows is a good way to study my work. Sorting through the slides, selecting sequences, and organizing them into a coherent flow that tells a story give me opportunities to notice mistakes, to see new details, and to make visual and emotional connections among pictures. Seeing the images projected in a different order with a curious, discursive audience present is thrilling and enlightening. The editing process for Web sites is similar, but the immediate feedback is lacking.

Many, many ideas for new photographs emerge during the editing-and-viewing process. Try to go public with your pictures.

Early in my career, I showed slides at informal brown-bag seminars of my university's biology department. Take your work to North American Nature Photography Association (NANPA) convention portfolio reviews and open screenings at American Society of Media Photographers (ASMP) chapter meetings. You'll meet other people with common interests, each of whom has new information and enthusiasm to share. In my case, friendships and collaborations resulted that not only are enriching, but have led to assignments, commercial slide shows, and book publication.

The final tool, which is crucial for better picture-taking, is patience. The ongoing process of learning how to visualize images, to recognize them when they present themselves, to photograph them creatively and professionally, and then to edit them takes time. This process is the lifework of a photographer. Whether you wait out one storm or a whole season or many years to get the shot you want, patience gives you the overriding confidence that you'll improve, prevail, and reach your goals. Even though you'll experience some disappointments, the rewards of patient diligence are great

Patience and endurance were largely responsible for this symbolic vision of calm— in reality a humble Nebraska farm pond, transformed by sunset and the ripple of a tossed stone. I needed patience to wait for the wind to die and the colors to rise, and endurance to withstand the cold air and biting flies, problems unimportant to the camera.

COMPOSITION

What makes you keep looking at a photograph? Surely the subject matter, or what the picture is about, is a first interest. But after the initial glance, composition is what holds your attention and keeps your eyes exploring the image. Composition is the arrangement of lines, shapes, and colors within a space. In photography this space is the camera's viewfinder. The photographer's job is to collect bits of the universe and put them inside this frame effectively. The entire context of each photograph is contained there, communicating the photographer's idea of a bit of the world to the world inside the viewers' mind.

You don't need a camera to sense how composition works. Scan any picture, in this book or anywhere else, and pay attention as your eyes move around in the picture, drawn by the organization of design elements, contrasts, and color. Lines, curves, circles, spirals, triangles, and their combinations are some of the elements of composition that give both direct the eye and provide the brain with information. Composition is one of the most personal aspects of visual art. It derives more from emotion than from science; however, over centuries of artistic creation, many theories of composition have evolved. Still, the basic question remains:

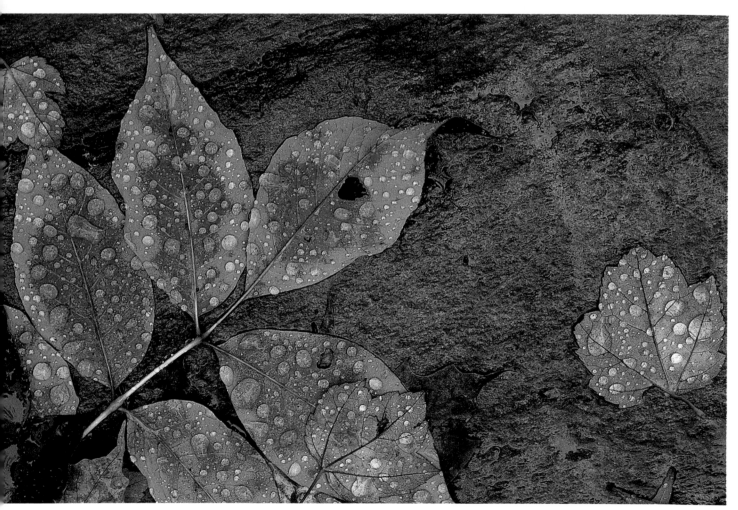

Composition can be a complicated combination of colors, shapes, angles, and positive and negative space, as in this rainy-day scene of hickory and striped maple leaves. The angled stem, the position of the leaves closer to one corner of the frame, and the inclusion of three maple leaves were all conscious decisions.

How does a photographer decide to compose a photograph? In many cases, the solution is as simple as recognizing what the subject of the picture is and then trying various angles and lenses until the subject is best conveyed. Sometimes the answer involves selecting from a scene only those objects that will command attention. Other scenes might require repetition of similar elements to underscore the meaning.

Color is an effective device in composition. The eye is drawn to brilliant colors, especially if darker areas or complementary hues that create visual energy or contrast set them off. In striving for compositional balance, remember that colors on the red end of the spectrum are much more powerful than soft blues are. In fact, a single spot of intense red or yellow can overwhelm even the strongest linear designs.

When an abundance of colors is readily available, selecting a few in a balanced arrangement is the best strategy. The primary colors—red, yellow, and blue-are a very active combination. A more muted effect results from using earth colors, such as ochre, olive, and reddish brown. Be conscious of how the colors you choose to include in the frame affect each other, and decide whether they enhance or detract from the mood you're trying to establish.

When you're standing in front of your subject, alternately looking at the scene and through the viewfinder, ask yourself what is interesting about the scene and why. Is it still interesting when framed in the viewfinder? Do some elements in the scene detract from the main subject and if so, how can you eliminate them either by changing the angle, focus, or lens, or by coming back another time? This exercise reflects the thought process involved in composing photographs.

As mentioned above, definitions and theories exist about some of the more common methods of composition. What follows is a discussion of some of these theories of composition and how you can use them in specific photographs of patterns in nature.

In some shooting situations, designing a photograph is somewhat simple. Here, the lines of the slate slabs lead down in a straightforward pattern and echo the veins in the leaf.

Positive and Negative Space

How lines and shapes are organized within the frame of your composition is of great importance. *Positive space* is a function of what lies within a pattern of lines; the part of the picture that lies outside the main subject shapes is called *negative space*. This could be just a neutral background for the main shapes, such as a blue sky behind a row of beautiful trees, or it could provide more contrast, as in the case of a brilliant sunset behind the trees. Positive and negative spaces in a picture can be interchangeable, as in the famous optical illusion of a vase that becomes two human profiles.

The relative intensity between positive and negative spaces is called *contrast,* and it is another important part of composition. Stark contrasts are one of the first compositional elements viewers notice. For example, a sharp line separating a dark hillside in the forest and a brilliant sky draws the eye away from the intricate pattern in the trees. If you want to accentuate the pattern of the picture, you'll need to tone down the contrast by avoiding or minimizing the strong line of sky. You can also increase contrast by depicting a combination of jagged and smooth shapes, manufactured and natural objects, or opposing lines or colors.

The spiral grain of a spruce drift log dictated the growth of this crustose lichen, but here the lichen's light gray tone becomes the positive design that catches your eye.

Balance

The relative size of positive to negative spaces and the contrast between them create the element of balance. The geometric form of balance is a perfect symmetry, as in an image of a flawless daisy or the mirror reflection of a mountain in a glassy lake. Images that are perfectly centered and balanced seem more stable, but because they don't actively draw the eye around the picture, they might become boring. A far more dynamic element of balance is asymmetry, which is created by placing the primary subject of the photograph off-center in the composition. This sets up a tension in emphasis between different parts of the picture—a topography of high and low points of interest for the eye to follow.

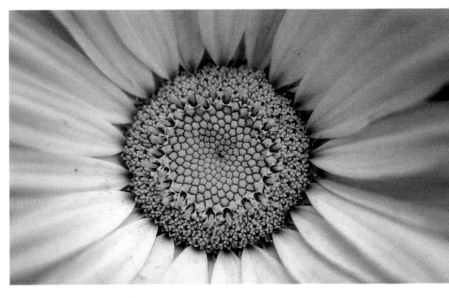

Perfect symmetry, as reflected in this closeup of a daisy, is rarely as visually exciting as an asymmetrical composition. Compare the way your eyes react to the centered daisy with the way they respond to the cactus flower on the left. Putting a bright red subject in the lower left corner of the frame makes you confront a saguaro's spiney hide, as well as a prickly pear's voluptuous flower. Your eyes are forced to travel between them and appreciate the contrast.

The Rule of Thirds

This is the most classic theory of composition. Discovered by early Greek artists and mathematicians, this rule articulates a long-standing observation that division of the frame into equal thirds, vertically and horizontally, is pleasing to contemplate. If you place your main subject on any intersection of the four dividing lines, you'll achieve a dynamic composition. This technique is often employed in landscape painting and photography. Centering then the horizon in an image might raise questions about whether the sky or the land is more important in the picture, thereby causing the viewers' eye to wander from one to the other uncomfortably. However, by moving the horizon line up or down until it defines two-thirds of the frame, you stress the part of the subject that you feel is most important.

The Rule of Thirds works so well and is used so often by photographers and artists that breaking it is a useful and surprising change of compositional pace. For example, you can place the subject on the very edge of the frame, or fill most of the frame with the entire subject until only a tiny sliver of sky is showing. But this kind of composition should relate naturally to a scene, such as when you're trying to make a subject seem tiny and lost in a vast, haunting space or when you bring a very large subject up close.

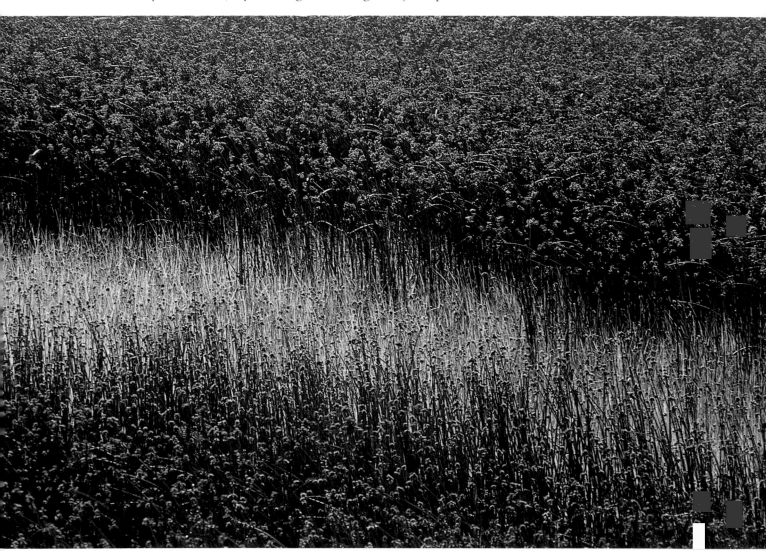

I used a 300mm lens to tightly crop the sedges in this California estuary, as well as to create a simple design from just the varied color of sedges along a tiny slough.

Scale and Proportion

Asymmetrical photographs emphasize other compositional elements called *scale* and *proportion*. These refer to the relative sizes of objects, rather than their shapes or lines. Using scale and proportion in composition can be as simple as including a distant tree in your photograph of a mountain to indicate how large the mountain really is. Proportion, which is related to the Rule of Thirds and balance, is a way of judging the position and size of an object in a photograph; it also relates to the actual number of objects or their relative sizes as revealed in the picture. A clichéd example of proportion is an image of a single yellow tulip in a field of red ones. This proportional ratio acts to connote individuality because it illustrates the relation of one to many.

Proportion interacts with scale as a compositional element in many traditional landscape pictures. Ansel Adams, who called landscape photography "the supreme test of the photographer," felt that "the intrinsic scale" was the most important element in a successful landscape picture. Giving viewers a sense of how vast and high the mountains are, or how distant the horizon is across the desert, usually requires the inclusion and control of many compositional elements. These might include a strong foreground with objects that not only indicate size but also are harmonious with the main subject. Having a middle ground that relates the distance that you would have to travel to reach the horizon helps, too. The most distant subjects—often mountains, but possibly clouds or forests—need to show enough detail so that viewers have a reference for the size of the subjects.

Combining these elements tests your ability to see relationships and to choose the right viewpoint and lens. Contrary to first impressions, an ultrawide-angle lens isn't always best for a landscape scene. Although this lens fills the frame with a lot of foreground, it renders distant objects too small. Short telephoto lenses work very well, bringing far mountains closer without flattening the perspective the way longer telephoto lenses do. An elevated viewpoint, even the top of a small hill or boulder, can

open the scene by revealing the important middle ground. Conveying scale in scenes of less range is a bit easier because pattern and texture become as important in sensing the need for scale and proportion recedes. It is a multi-step process for both the photographer and the viewers: first, there is an overall impression; then size comparisons are made that lead to compositional adjustments; and, finally, the scene's textures are reconsidered. What appears to be finely textured stone at first might really be a great mountain wall full of fissures. Eliminating all reference to true scale, as in a very tight closeup, is one of the gateways to abstract photography, which is explored later (see page 114).

A technique for telling the story of relationships in nature is to focus closely on a detail with a wide-angle lens and let the background be in focus or nearly so by choosing a small aperture. I was only inches away from these Siberian phlox in Alaska's Sadlerochit Mountains.

Framing and Focusing

Framing and focusing are related ways of making the eye move across the picture in a composition. Framing is the effect of surrounding the subject with something that emphasizes it in relation to the overall scene, such as a nest of brilliant blue robin eggs framed by the dark twigs of a tree. Focus is an excellent framing device; most viewers want to see things clearly and, when scanning a photograph, tend to fix on the sharpest detail. Using shallow depth of field can throw the background of the image out of focus, enhancing important detail and drawing the eye to the subject immediately. Use these techniques carefully so that the device of framing or soft focus doesn't distract viewers. Your subject should be of primary interest, and the technique you use to render it should not be obvious.

Pure color makes a wonderful frame or background for focusing attention on other elements in the composition. Experiment with colors that recede, such as light blues and grays, to compose your photograph's subject. Try different background colors with the same subject to see how color acts as a framing device.

Although a tiny backpacker is the focal point of the top picture, the "reverse mountain" effect of folding him in black angles downplays his significance in the landscape. I shot this scene with a 200mm lens near Mount McKinley.

One of the tradeoffs of natural-light, closeup photography is that you often have to work with wide apertures and learn to deal with shallow focus. This approach has become one of my hallmarks and a creative tool that I chose to employ by letting the asters go out of focus in order to frame this brilliantly colored sumac branch.

Point of View

Most people agree that carrying on a conversation is more rewarding and interesting when you are knowledgeable about the subject and have a belief system that guides your opinions—in other words, an informed point of view. The same can be said, in a slightly different sense, about nature photographers. Knowledge of the subject should be combined with an original and powerful point of view to make the best possible photograph. A good photographer needs to take a fresh look at every subject by viewing it from all sides, thinking about its shape and the way light hits it, and imagining it from various angles with various lenses. These perspectives help define your point of view and enable you to photograph with a deep understanding of your subjects and the meanings you bring to them.

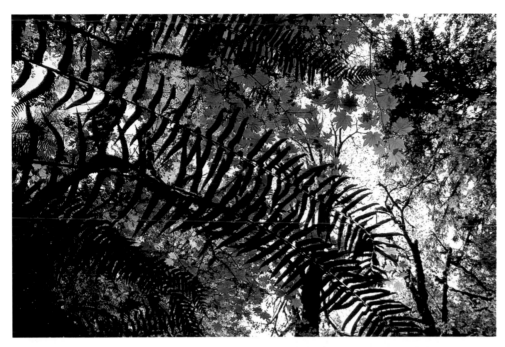

I shot the top image of understory layers of growth with a 20mm lens from an unusual point of view—that of a small animal crouched, as I was, beneath the branches of a sword fern. Raising the camera and turning it 180 degrees to focus on the forest floor produced the bottom picture. It reveals the complex shapes and textures of plants and their interrelationships in old-growth rain forests.

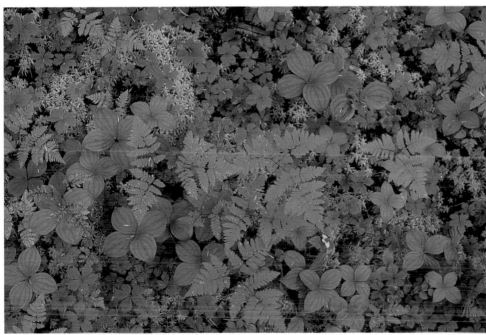

Creating Perspective

This farm scene in Oregon was an attempt both to include human life within a natural pattern and to evoke a certain perspective about time and the seasons as well as distance. Throwing the house out of focus sets it apart from the rosehips in the foreground and adds to the feelings of melancholy and separation implicit in autumn. But the rosehips' seeds promise that spring will come again. I exposed for the highlights here.

One of the wonders of a two-dimensional picture, whether a painting, video image, or photograph, is that it can convey strong impressions of perspective and depth. By now you have several visual tools for adding a feeling of distance or inner space to your photographs, but you still have others to consider. As discussed earlier, color is a compositional device that can create strong perspective. The aggressive colors—reds, oranges, and bright yellows—move to the visual forefront in almost any photograph. In fact, these colors are so prominent that it is wise to watch out for distracting bits of them in the frame; after all, you don't want them to pull a viewer's eye away from the main subject of the composition. Blues, purples, and greens, on the other hand, tend to be regressive colors, receding into the background and creating a sense of distance.

Objects appear to get bigger in your field of vision the closer they are to the foreground. This is certainly true for objects of estimable size that are assumed not to shrink as they recede into the distance, such as trees, people, and birds in a flock. The best lens choice for accentuating the large size of nearby objects is a wide angle because its large field of view tends to enhance the roundness of close subjects and makes the apparent size of other objects diminish quickly with distance. Wide-angle lenses can convey a great sense of depth and three-dimensional space.

The constancy of parallel lines is another depth-of-field cue that is connected to the concept of relative size. For example, two sides of a street don't actually get narrower in a wide-angle view. They just appear to converge because of the distance produced by lens distortion.

Dimension can also be created by using detail. Usually, the closer an object is to the lens, the more detailed it will be. Atmospheric conditions like haze, fog, and dust obscure the most distant objects; in the absence of other visual clues, the hazier something is, the farther away it appears.

Fog makes approaching strangers loom larger than they are because it obscures distance, and you're fooled when you see someone closer than you expected. Even on clear days, air molecules and the tiniest dust particles result in a blue cast across distance, and mountain ridges become successively more silhouetted and bluer the farther they recede in the distance. Dust and light ground fog make a white or neutral wash across distant mountains that usually is brighter near the ground.

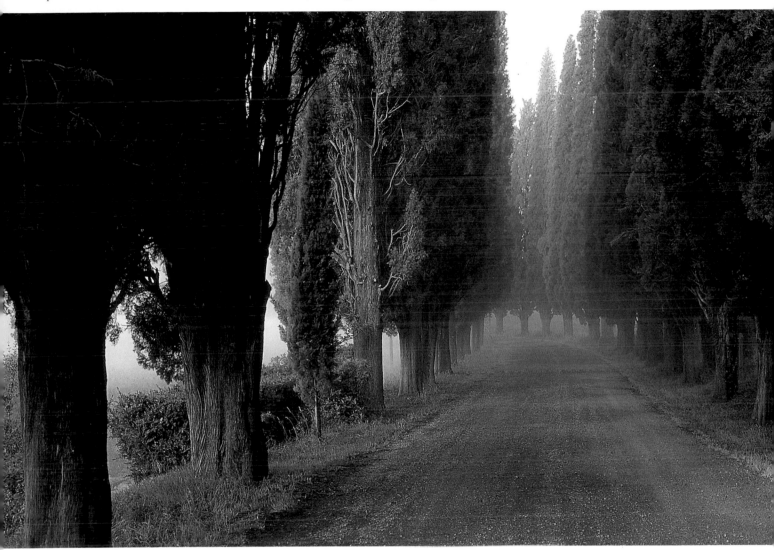

This kind of scene is a symbolic image that takes almost no thought to recognize or compose. Setting it apart at least a little are the curve in the road and the light fog, which increase the sense of distance and mystery.

Shadows

Shadows add another dimension to shapes, produce a counterpoint in patterns, and are a neutral stage on which to play up color and texture. Where shadows come from is usually obvious, yet the ways they can be used in nature pictures are not always apparent. Shadows create their own world of shapes; they can curl up a cliff side, undulate across rolling ground, and wrinkle like scarves flung over stones.

The blackness of shadows can be controlled somewhat by your exposure. An average exposure reading the camera meter recommends for a sunlit portion of a scene usually accommodates some visible shadow detail.

Underexposing the scene by about one stop to enrich the color of the sunlit parts will render the shadow mostly black; underexposures of two or three stops will create completely opaque shadow images. Generally, the blacker the shadow, the more it contrasts with the sunlit parts of the image and, thus, gains in compositional strength.

Small shadows are graphically useful, too. Like silhouettes, they provide information about the shape of a textured object while simultaneously abstracting it. Shadows, however, can be a problem if they obscure important detail, which is why some textures shouldn't be too underexposed.

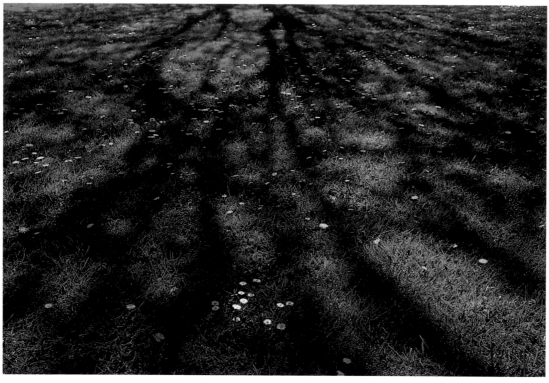

To transform the shadow of this apple tree into an appealing image, I ignored the leaves, trunk, and sky altogether, creating instead a phantom, upside-down portrait with my 28mm lens. Although the shadow is an echo of the tree's roots, the daisies and dandelions on the lawn bring you back to the surface.

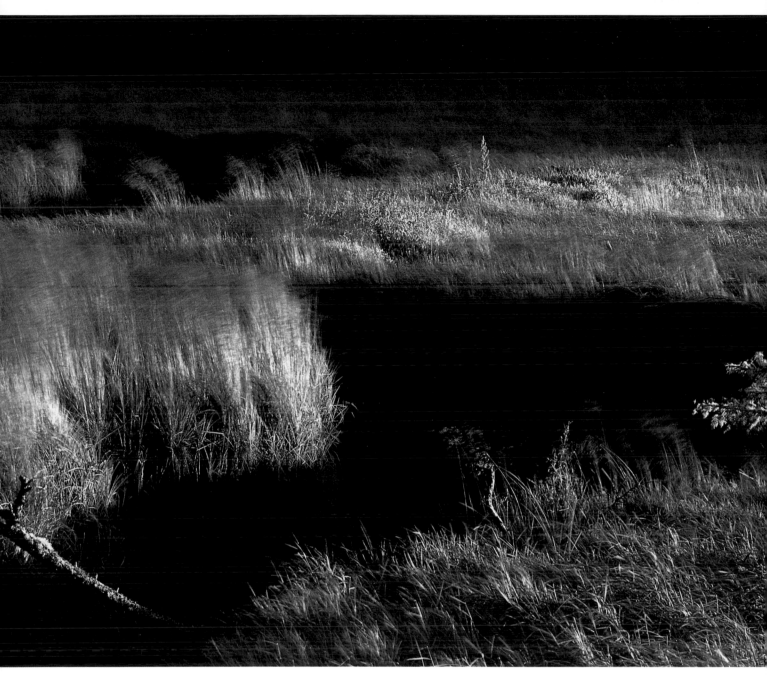

An angular shadow, meandering through an estuary filled with windblown grasses, sets off the greens, yellows, and golds in this graphic composition, which I shot with a 105mm lens. On assignment for Audubon *magazine, I used a slightly long exposure to capture the wind's movement in the grasses*

Reflections

Reflections occur when the light from a bright object bounces off a smooth, dark surface. They can effectively increase the graphic interest in a shape or pattern and create magical mirrored illusions of sky, earth, and water. Reflections don't only repeat the shapes being photographed. One moment, they can flow, pure color and light, playing across the surface of water, and the next moment let you peer into the looking-glass world of strange juxtapositions.

The morning hours, when the air is still, are best for searching for reflections. Sub-stantial depth of field is essential for reflections because the virtual image, which is the reflected image of the subject, is the same optical distance away from your camera as the subject itself. In order to keep the reflection in focus, you need the same depth of field required to make a photograph of the subject. You can see this in your viewfinder; if you try focusing on only the surface of the water, you get a crisp picture of the water with some out-of-focus regions resembling your reflection. When photographing reflections, I often like to keep everything in

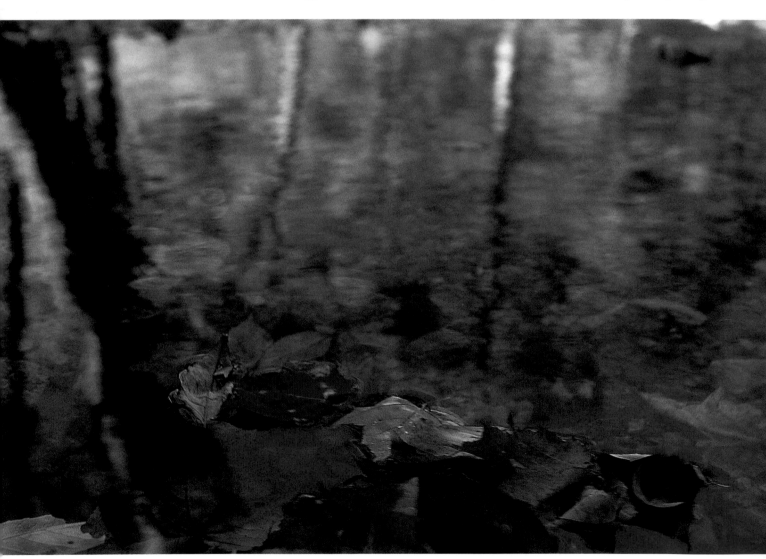

The search for a new perspective on the cliché of fall leaves in a pond continues every fall. Here, I turned to my wide-angle lens and, splaying the tripod legs to get the camera inches from the water surface, captured the slight motion of the leaves in the foreground, the curving shore beyond, and the reflected trees in between.

focus, including any objects floating on the water, for maximum visual interest.

If too much reflection is a problem, careful use of a polarizing filter, or *polarizer*, can control some of it. Turn the filter slowly while looking through your viewfinder until the unwanted reflections are gone. Completely eliminating the brightest highlights on water usually is impossible with a polarizer, and a ghastly metallic blue sheen often remains. When very bright highlights appear in the image, close the polarizer down only a few degrees.

The magic in water reflections is so powerful that it is easy to be mesmerized by one view. Stay alert to other compositions. Examine this photograph from the Great Smoky Mountains to see various images. Be sure to turn it upside down, too.

Reflection as pure points of light is part of the subject of this monochromatic 200mm view of Matsushima Bay in Japan.

Rhyming Shapes

The manipulation of rhyming shapes can lead to another kind of compositional magic. Two daisies together make a strong image, but I don't consider these shapes to be rhyming any more than a poem that rhymes "ear" with "ear." That word rhymes more interestingly with "hear," or "deer," or "atmosphere." Like word rhymes, rhyming shapes convey a sense of play—only they do it visually. For example, if you happened to find a daisy at sunset and could find a way to relate the yellow center of the daisy with the yellow sun in the same photograph, you'd have a stronger visual rhyme. Wandering the mountains might reveal tiny stones with shapes that echo the surrounding summits. Many objects you see remind you of other things, and collecting them in single photographs or in a series is a great mental exercise in the process of learning to see rhyming shapes, reflections, and shadows. I often don't discover them until the editing stage.

This tiny, umbrella-like Lomatium nudicale in the foreground mimics the shape of a great white oak in the background.

An odd, alien-looking bamboo shoot seems to dance to the same music.

Relax and Look Around

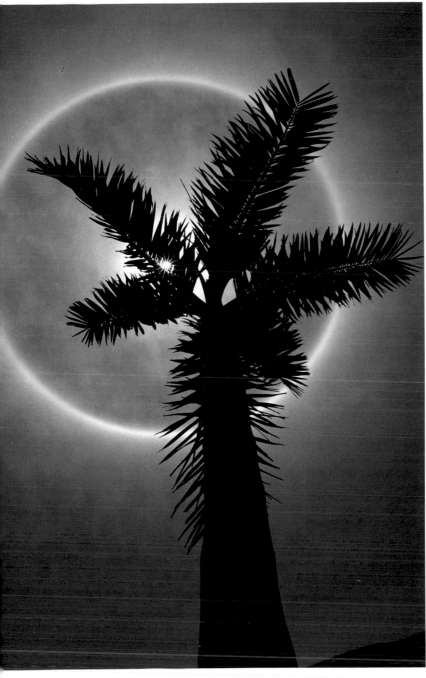

There are so many ways to organize elements in photographs, and so many things that lead the eye, that the creative photographer should consider the rules of composition discussed here as mere suggestions. Composition is a difficult subject to codify because it is so personal and emotional, depending to a great extent on how the parts of a photograph feel, rather than on more technical aspects, such as the relationship between aperture and shutter-speed settings. Your own experimentation and study will produce the results that work best for you. It is important to practice seeing how composition works until it becomes as natural and immediate a response as focusing is. You can do this with any image, anywhere. Practice by analyzing, for example, magazine advertisements, page layouts, room-furniture groupings, art arrangements on a gallery wall, and motion pictures. Most important, check how each composition works by carefully looking at the image in your viewfinder before you click the shutter.

First, compose yourself, and take a moment to relax. See what is in the image that the frame encloses. Notice the direction your eyes travel as they scan the scene. Consider the message that the composition of the subject's elements conveys. Let your camera move, and let your eyes explore the subject and those elements that are important to you. Do you like the image that the frame separates from the rest of the world? If you do, and your exposure is set, press the shutter.

A palm tree, photographed with an f/22 aperture to capture an atmospheric circle around the sun in Yucatan, Mexico, picks up the same radial and silhouetted motifs shown in the images on the opposite page. Sometimes rhyming relationships between images are only apparent when they're viewed simultaneously, which is really an editorial process.

CREATIVELY COMBINING PATTERNS

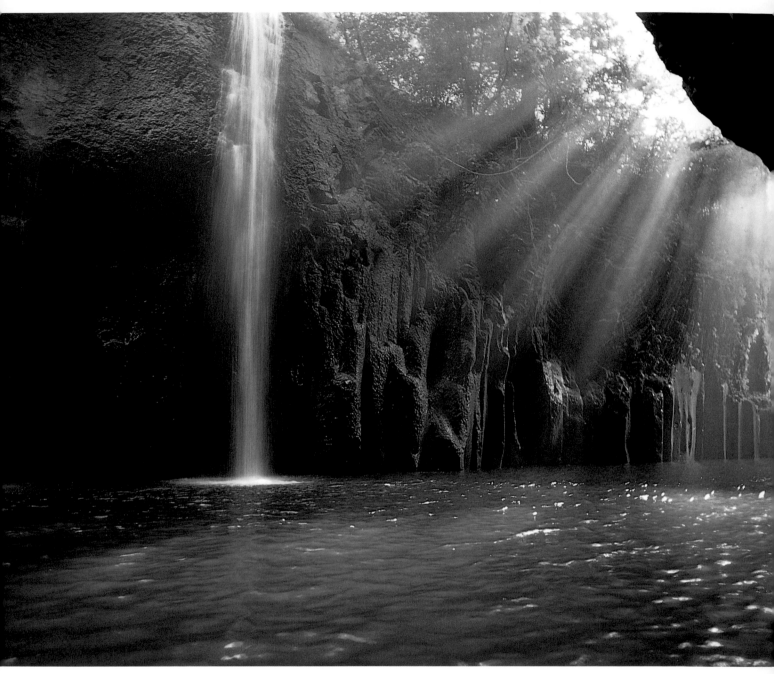

In this image of a waterfall in Kyushu, Japan, strong lines create a dynamic composition. To capture the mist-laden sunbeams and smooth the water's surface, I used a 1/15 sec. shutter speed with a 20mm lens and carefully handheld my camera while shooting from a swaying rowboat. I metered off the back of my hand to determine an exposure to start bracketing from. Then I positioned the boat so that the cliff blocked the sun but permitted misty sunbeams to escape for my camera.

It is rare to find a natural design unrelated to other patterns of nature. In concert with the elements of weather and light, patterns move, play hide-and-seek, and crowd together, making your photographic task sometimes more difficult than finding the proverbial needle in a haystack. But with an understanding of the basic patterns of nature, as well as a grounding in the processes of visualization, experimentation, and composition, you can now explore photographs that effectively combine several patterns.

In the photograph of the waterfall in Kyushu, Japan, the diagonal, optimistic sunbeams brighten the severity of the black basalt walls and add interesting visual echoes of the waterfall. The sunbeams, transformed into a fan shape via the perspective of a wide-angle lens, also draw the viewers' eye to the right into a bright sky. They provide a psychological as well as visual escape from the claustrophobic effect of the narrow gorge. This photograph evokes mystery because of the contrast between the brooding overhang

of the right-hand cliff and the delicate mist and falls. The watery foreground, which makes viewers feel that there is no place to stand, enhances the visual quality.

When sets of diagonal lines are combined with straight, vertical, or horizontal lines, a sense of implied movement and direction is added to the picture. Contrast increases when straight lines lead to, or grow into, curves that culminate in circles or spirals. The energy in the composition increases as the viewer's eye is drawn along straight lines, only to be pulled aside onto those that curve and cross. Perhaps the strongest contrast is between a straight line and a circle, as if comparing an ongoing action with a completed cycle. The circle might be a part of the same set of objects as the line or could be introduced in the background through lens flare.

Photographs whose subjects combine the attractive natural patterns of curves and circles with other shapes tend to be powerfully composed. A very graphic relationship exists

Diagonal lines that bend into curves convey a sense of harmony as well as movement. I used a macro lens to make this half-life-size image. An f/5.6 aperture rendered the dew in detail and the grass blades in soft focus.

between triangles and curves; for example, the curves found in a wispy cloud contrast quite effectively with a jagged peak above a cascading river. Much more subtle is the interplay between curves and circles, which reminds you of the complements in nature, and the unity and purpose implied by shapes that are strongly three-dimensional. In images with pattern and texture, subtle curves lead the eye and highlight certain parts of the design. Finding curving nuances in an otherwise even pattern takes skill, but some are obvious, such as when a line of flowers forms a sweeping curve.

Patterns of rocks, mountains, trees, plants, and animals are everywhere combined with others, sometimes in dizzying complexity.

Although it is possible to fit many disparate design elements into the frame of a single photograph, more successful images will result from combining only a few patterns with one powerful shape. Since a strong shape will dominate a photograph, the other elements must be selected carefully and can add crucial information about scale, place, time, season, and motion. It will serve you well to search any photographable landmarks for those shooting angles that render the most balanced compositions. This sometimes means choosing a lens that reduces the apparent size of a shape or includes only part of it within a photograph. This strategy can also be used to highlight interesting portions of a shape.

Spending some time with creatures at their level also leads to a three-dimensional view of their environments. I don't know what this spider was perceiving as I focused using my 105mm macro lens and extension tubes, but I certainly noticed the brilliant effects of sunlight coming through the palm fronds.

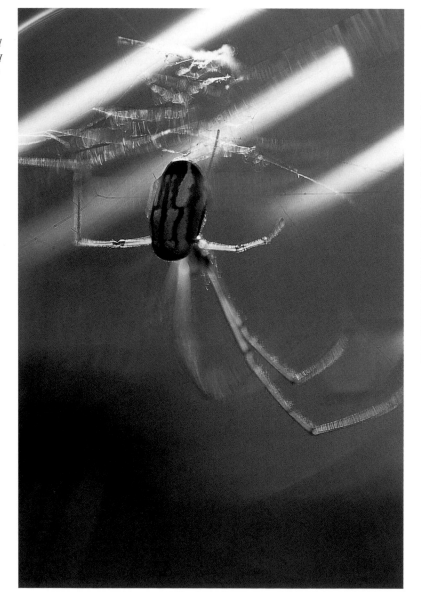

A few autumn leaves weather a driving rain on an old alder tree in British Columbia's Queen Charlotte Islands. Three patterns are combined in this image: a random sprinkling of green leaves; a background of straight, vertical trees; and the curving, horizontal branches of the alder.

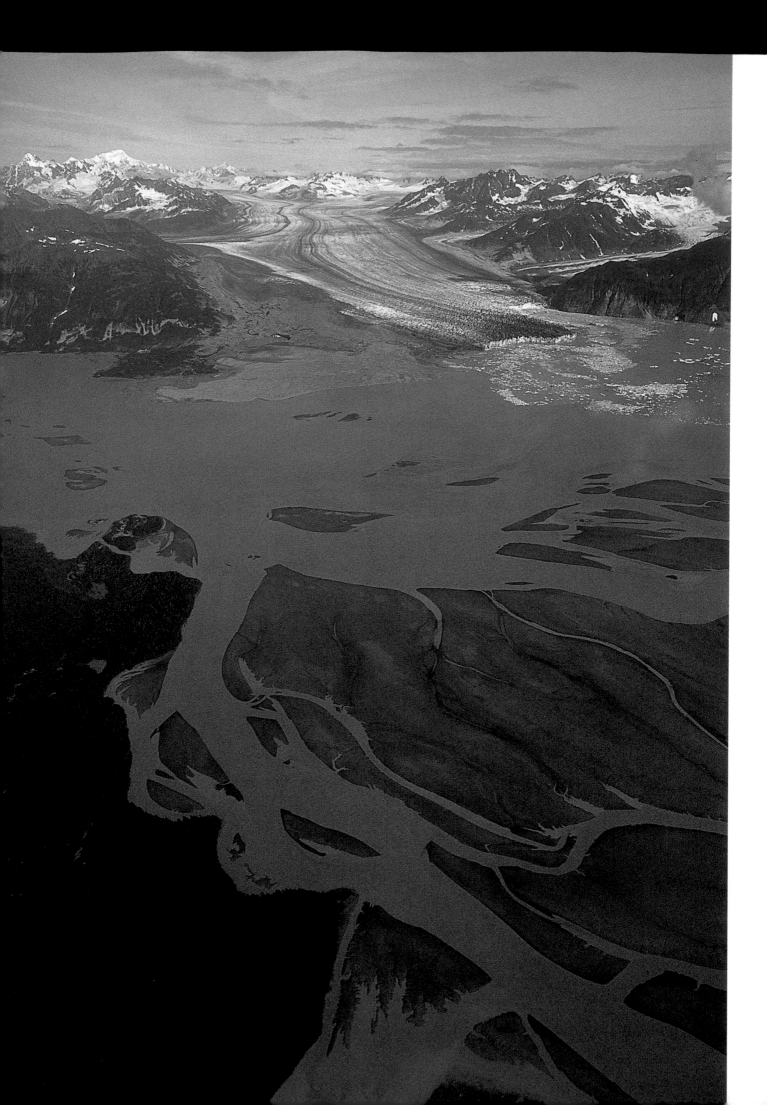

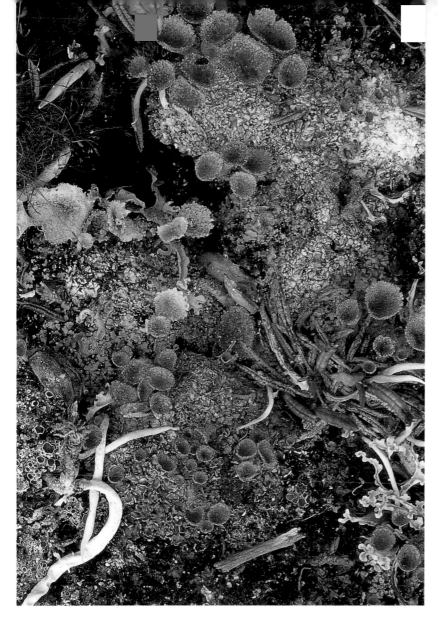

As you learn to photograph more closely, the elaborate, extravagant richness of pattern in the world opens to you. In this 3-inch patch of arctic tundra are at least 10 individual plants (and probably many tiny insects). Each has pattern and texture down beyond the cellular level. With time enough, equipment, and patience, where do you stop?

I captured this study in texture by shooting with a 300mm lens from the edge of Highway 1 on the Penobscot coast of Maine, isolating just a small slice of the rich estuary sedges. I was particularly attracted to the interfingering colors, probably influenced by such Expressionist artists as Clyfford Still.

Many flow patterns are evident in this geologic study of the terminus of Miles Glacier on the Copper River in Alaska: muddy braided river channels, parallel moraines on the glacier, dedridic estuary streams, and sinuous flows. Many landscape shapes and fractal patterns are also visible in this photograph.

ABSTRACTIONS AND SYMBOLISM

In everyday life you make many assumptions about what you see. But you can question these assumptions by turning something recognizable into a new object for perception. Lens choice, composition, contrast, point of view, color, and other elements of a picture are the photographic tools you'll use to this end. Once you begin creating abstract or symbolic images, the act of seeing becomes more complex—and much more interesting. My definition of landscape has expanded beyond most others' definitions. Based on its root word "land" and "scape," I understand "landscape" to mean "condition of a region." So I classify stones, waves, individual plants and trees, and even buildings and the people who built them, as possible objects in the landscape. More and more, I experience the process, network, design, and illusion of life all around me. As a result, my photographs include more symbols, emotions, and multiple meanings, and, I hope, speak eloquently for the preservation of the earth.

This section explores the realm of symbols and abstractions, and how to make the jump to a photography filled with more personal meaning. Symbolic and abstract images confront the mind directly with new connections and new ways of seeing, communicating as much or more through feelings as through facts.

Whenever I see this photograph of maple leaves floating on the Concord River, I remember the moment I was arched over the rail of a bridge, framing the picture in my camera. Even though the dark green water the leaves were floating on looked like water and I knew the actual size of the leaves, I also knew that an underexposure would turn the water black, creating a perceptual illusion in the photograph. Later, when my friends and I looked at the image, the illusion retained its power: we imagined leaves, raked from a space station in autumn, floating gracefully across starfields. By creating this image, I made the leap from reality to a much more abstract photographic message.

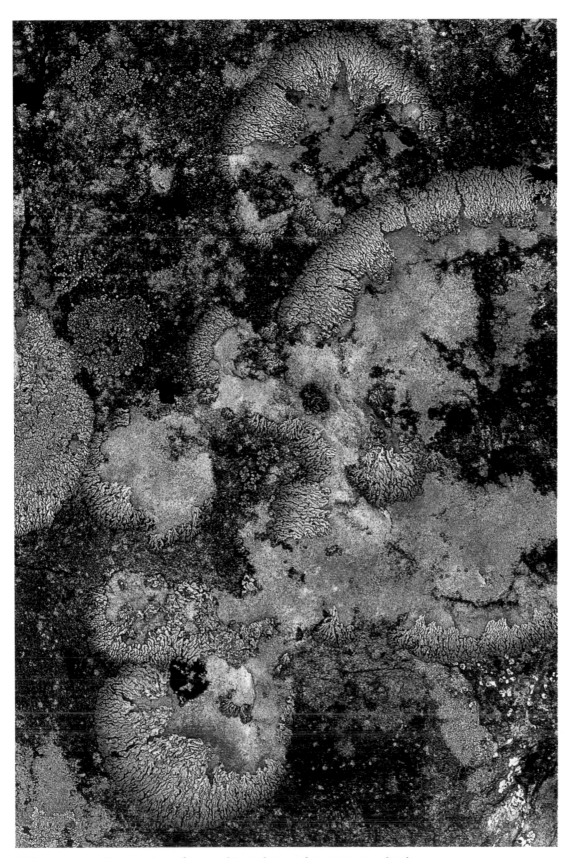

Lichens are sensitive monitors of air quality and, since they grow exceedingly
slowly, are good indicators of the time their substrate has been undisturbed.
This environmental reality shouldn't interfere with an abstract artistry. This old
lichen, its thallus peeling off to reveal clean rock, looks like exploding moons.

Abstract Images

Every photograph is an abstraction, because you are reducing it to its intrinsic essence or form. A photograph of the Grand Canyon is not the Grand Canyon. The very act of putting a frame around something changes your perception of it by isolating it from its context in the real world. Nevertheless, photography is considered essentially a realistic medium, and its verisimilitude is often mistaken for what is real. Thus, it is capable of fooling you.

In everyday language, you can tell exactly what the subject of a realistic picture is, but it is more difficult to quickly understand the subject of an abstract picture. In the art-school sense, abstraction is an arrangement of colors, patterns, or shapes that has been set loose somehow from the world of immediately recognizable objects. These images come rather easily if you crop in tightly on something, eliminating natural borders, using novel viewpoints, and making designs based on your own aesthetics rather than on only nature's.

Between the extremes of the absolutely realistic and the completely abstract lies a great deal of territory, and just because a subject is unrecognizable at first glance doesn't make it abstract. Nature is not abstract. What you see is perfectly real, natural randomness or the results of growing, changing systems. Photographer Eliot Porter, who valued order and extreme sharpness in his landscape images, wrote that he came to realize that many scenes also "emphasized the random chaos of the natural world—a world of endless variety where nothing was ever the same." He recognized "a tension between order and chaos," and he knew that "only in fragments of the whole is nature's order apparent." In other words, the artist chooses what to focus on from the never-ending wild and changing processes of the world, but it is all real. As you explore a scene through your camera, you can become lost in a sea of confusion one moment and then wash up on the safe shore of a strong pattern.

The most intriguing images contain mixtures of shapes, designs, symbols, textures, and scales—uncertain meanings for viewers to uncover. Those mysteries, and the way they stimulate your imagination, make creating symbolic nature patterns so rewarding.

Moving in with a 200mm lens, I shot progressively more abstract images at sunset on Oregon's Rockaway Beach. In the first shot, the camera frames an entire sea stack (above). In the second shot, bands of color in the water challenge the cutout shapes in the rock for attention, but some semblance of reality remains (directly above). In the last shot, however, the focus is on the essence of the sunset—pure color—without any reference to land or sea (opposite).

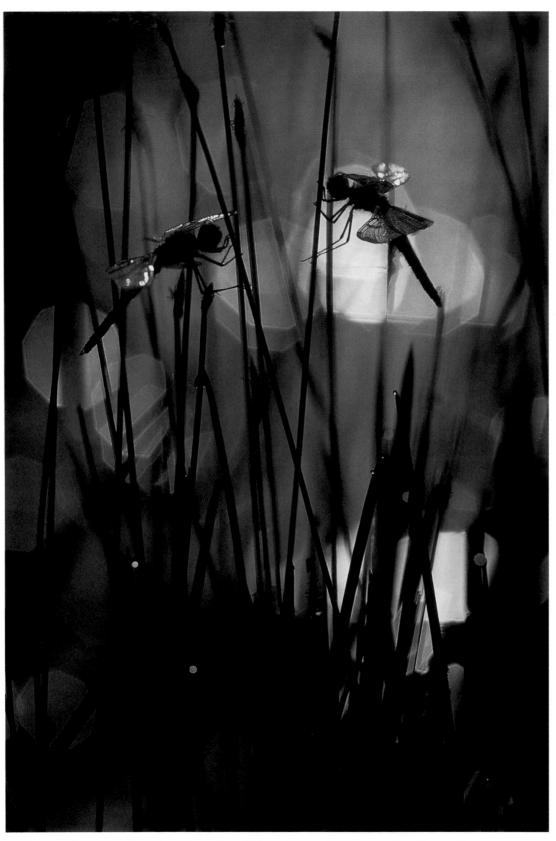

By shooting from a very low viewpoint with a 300mm lens and extension tubes, I was able to get reflections of the sunrise on the wings of these calico pennant dragonflies perched on sedges. What many people see in the golden light, though, are fairies or angels—an emotional response actually not far from my joy when I made this photograph.

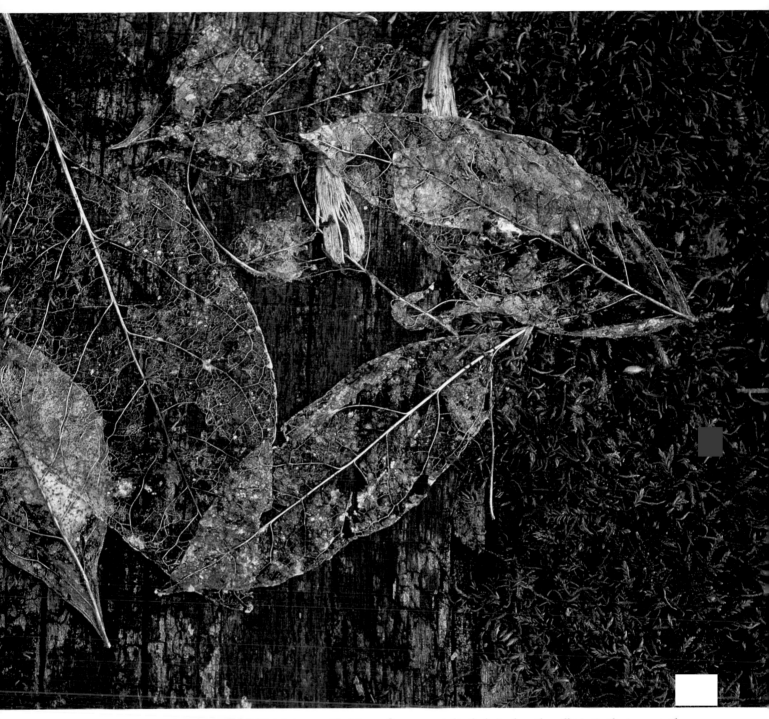

Skeletons often suggest death, but when they illustrate the process of decay, like these disintegrating leaves do, they also symbolize the passage of time and its infinite transformations.

The prehistoric effect of this view of Ingalls Lake in Washington's Cascade Mountains seems to come from the strangely shaped, almost animate rocks in the water; the round boulders on shore; and the mist that imparts a sense of psychological distance from these subjects. Shot at dawn with a 55mm lens, this image has been a continual seller, and no one has ever complained about the tree being dead center.

Screw Auger Falls is a weird name on the map. But when you finally reach the brink of these cascades in the Gulf Hagas reserve in Maine and see the strong radial effect of the carved waterways, you understand. I used a 20mm lens to accentuate the vertigo.

Part Three

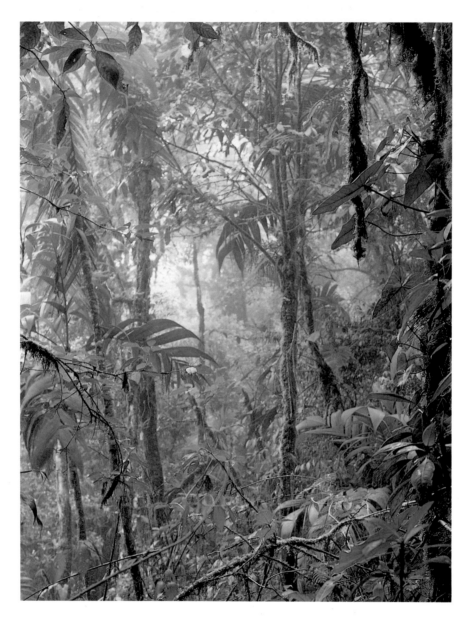

THE BUSINESS OF PHOTOGRAPHY

AH, TO BE A NATURE PHOTOGRAPHER! The carefree, nomadic life: constant romantic adventures in the world's most beautiful places, and the freedom to make pictures on a whim, while the top nature publications wait eagerly to publish them. Sounds great. Well, every successful career in nature photography does have some of these perks. But the truth is that many people are drawn to a career in nature photography, as I was, because of a love of backpacking, nature study, and the ecology movement. Most maintain the more earthbound lifestyle of hobbyists or scientists with a clear passion for their work, even after they begin selling their photographs professionally.

This photograph of Costa Rica's rain forest, made during a nomadic period of the most earthbound, slogging kind of backpacking, reflects my passion for conservation and dedicated science. A friend in the International Program of the Nature Conservancy had arranged a place for me on a small biological expedition to explore a newly protected mountain ridge for Costa Rica's national park system. Called "La Zona Protectora," the ridge connected the lowland rain forest and the mountaintop cloud forests. It had escaped destruction by the heavy logging and ranching projects that have decimated so much of Costa Rica's mountain jungles. The ridge is a priceless pathway for wildlife and an excellent place to study the rain forest at all elevations.

This was my first time in the tropics, and I learned some things the hard way. One night I went on a journey down a steep side canyon at twilight to photograph bats being captured with finely woven mist nets. Within half an hour I was lost, my flash units shorted out in a downpour, and all I could do was helplessly watch as my headlamp batteries faded on my way back to camp. Another day, trying to negotiate a swamp by gingerly walking across tree roots while carrying a 75-pound pack and my camera, I slipped into a seemingly bottomless hole and was saved only because my tripod got wedged in the roots.

But during three weeks of moving observantly up "Volcan Barva" in La Zona Protectora, I learned about hundreds of plants, animals, insects, and phenomena from the team's scientists. I also had time to wait for the most evocative magical light, in which I made this photograph. The right combination of atmosphere, light, and strong forest shapes was, however, elusive until I reached an elevation of 4,500 feet and mist began blowing down from the summit. As it created an increasing sense of depth, I loaded my camera with Fujichrome 50 and composed with my 105mm lens, creating a frame of philodendron leaves to accentuate the depth. Upon my return home the image became a new classic: It was used to illustrate the subject of biodiversity in *Scientific American* magazine, became a greeting card and a postcard, and was published frequently in biology texts and on conservation-publication covers. My stock agency put it in a catalog, and it became my best-selling photograph for eight years. This picture also reminds me how essential outdoor-travel skills and perseverance still are for getting a great photograph, as well as how my career has evolved from taking nature photographs on a whim to doing professional assignments that stress the importance of conservation.

BECOMING A PROFESSIONAL

In the early 1970s, when I first tried to interest New York editors in my work, I actually stuffed 100 of my best slides into my backpack, pulled on my hiking boots, and hitchhiked all the way there from Oregon. At that time nature photography was still rather peripheral to most of the "real-world" professional fields of publishing, advertising, and business. It was considered immature and esoteric for an adult to want to photograph trees, mountains, flowers, and animals exclusively. Although a few nature photographers were successful and some magazines, such as *Audubon,* were publishing their work, the field was narrow. Even Ansel Adams hadn't yet been discovered by the world at large as a nature photographer.

This certainly has changed over the years! Today nature photography occupies an important place in the mainstream concerns of a world in environmental crisis. Both as a hobby and a serious profession, it has never been more popular. Thousands of amateur photographers and professional photographers working in other photo specialties shoot nature because they love it. Many people make nature images out of concern for the diminishing resources of the natural world. The continued growth and automation of the technologies of photography, the perceived lifestyle, and the lure of being published have also spurred interest in nature photography as a career.

It is hard to pin down the number of active, professional nature photographers. Based on subscriptions to her services, Ann Guilfoyle, head of AG Editions, a marketing service and Web site for outdoor photographers, estimates well over 1,000 photographers actively work to sell their images. Of the 1,500 members of the North American Nature Photography Association (NANPA), about 45 percent say they are professional. And about 1,030 members of the American Society of Media Photographers (ASMP), list nature, animals, landscape, scenic, underwater, or wildlife photography as one of their specialties. Guilfoyle says that probably only about 500 photographers are able to support themselves in full-time careers. Most of those photograph other subjects also or have other sources of income.

Environmental photojournalism is also a strong area of interest. Photographers for newspapers, magazines, and organizations document the riches of the natural world, as well as its unparalleled destruction, and they are serious about alerting everyone to the threats to the earth. Nature photography appears in every major newsmagazine around the world. Its use symbolically or for the "green" image makes it ubiquitous in advertising. Throughout the 1990s, books on nature themes and the environment proliferated, even while conservation groups and issues survived several slumps of public interest. Naturally, the approaching millennium brings renewed attention to the earth, its wonders, and its condition.

Most successful nature photographers are professional and business-like, and are often driven by a purposeful love of their craft. A large number maintain careers in other fields, yet their part-time photography yields important images. The work and sacrifice that go into making great nature pictures is not for everyone. The job can include rising before dawn and remaining out until long after sunset day after day after day, spending many uncomfortable hours in a tent or blind waiting for the perfect image, slogging through tropical forests, trekking the Arctic, and climbing mountains, carrying as much as 80 pounds of photography equipment.

Committed professional photographers maintain high standards of integrity and honesty in all aspects of business: working with prospective clients, planning assignments, and maintaining contracts and stock. Because of their prominent environmental concerns, many nature photographers have a powerful sense of ethics and refrain from harassing animals or damaging landscapes for the sake of a photograph. The NANPA "Principles of Ethical Field Practices" is an important codification of these concerns. Photographers

often refuse to accept assignments or provide photographs for groups or corporations with policies inimical to protection of the environment, and many pros donate their time and images to conservation groups. They do this in spite of very heavy competition that keeps pay rates low compared to those for corporate and advertising work.

To have a career in nature photography, you must be alert and driven by an insatiable curiosity, as well as be motivated to carefully plan and carry out long-term projects that often are self-funded and self-generated. In today's business environment professionals must have a thorough understanding of contracts and copyright law, and be active promoters of their work. This section presents an overview of the most important aspects of the commercial world of nature photography.

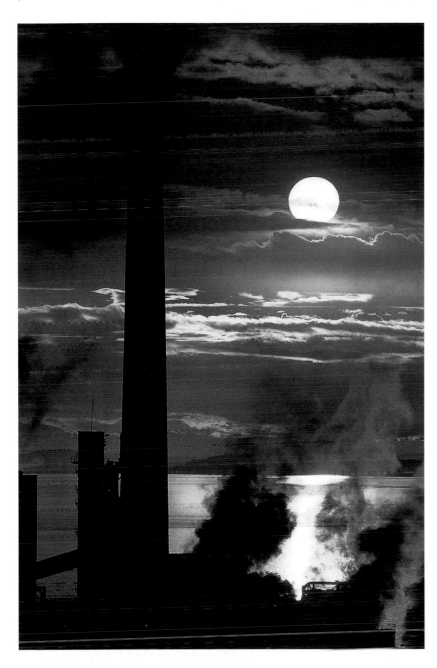

During the 1990s, special-interest politics has stymied new conservation legislation, which has been falsely painted as a drag on the economy. Environmental groups have often fought defensive battles against seemingly endless assaults on the natural world. I've made many images of pollution and sprawling land use, which are continually used in brochures, textbooks, and magazines.

DEVELOPING AN ASSIGNMENT

Although the end result of photography is often a single great photograph, the starting place is the assignment. Many pictures are exposed during the search for that ultimate image. Making successful pictures on even a short assignment requires preparation, the right equipment, and professional discipline. Most photographers dream of the day when an editor finally calls with a first assignment; after that they live for the day when they receive a call about the next one.

Unfortunately for most nature photographers, the telephone rings all too infrequently. Few assignments are given out compared with the large population of eagerly waiting and available talent. This is because many businesses and publications use already existing stock pictures to satisfy their photography needs. So in order to shoot the pictures they want, in the places they want to go, nature photographers often create self-assignments for love and profit. However, whether you are on a professional *National Geographic* assignment, a self-assigned trip to Africa, or a short personal weekend trip to document a spider-filled meadow, the keys to good photography are planning, paying attention to your equipment, and being disciplined enough to reach for your goal until the great image is yours.

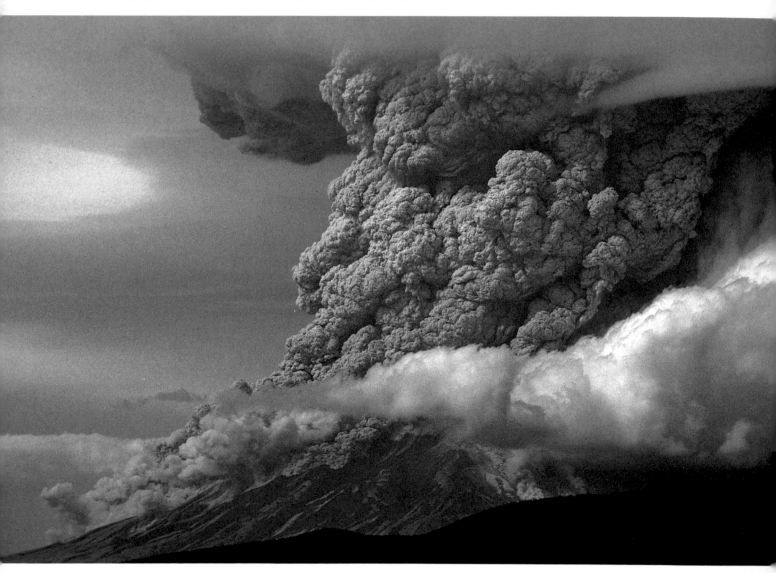

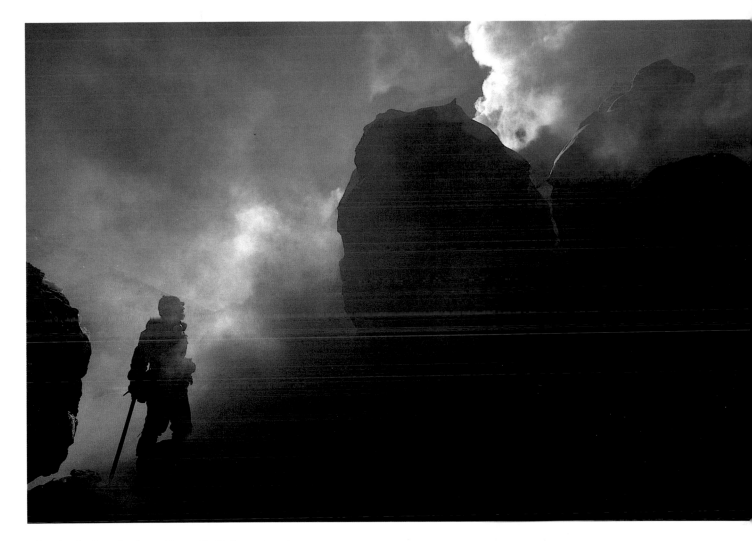

I lived only 40 miles from Mount St. Helens when it erupted in May, 1980, and my photograph of it, on the left, sold almost immediately to Smithsonian magazine. For the first time it occurred to me that as a nature photographer, I could make newsworthy images of an important, ongoing event. Developing a network of pilots and friendly geologists as well as a plan for continuing coverage, I began actively marketing volcano and regrowth images and have now made more than a thousand sales. In 1985 I completed an assignment for Life, shown on the right, and one of the unpublished images from that shoot—a geologist confronting the active lava dome, shown above—later appeared in my book, The Northwest, as well as in Photo/Design magazine.

Planning

For me, planning an assignment is the last step in a long process of acquiring a broad knowledge of nature, geography, and current events. You should read as much as possible about the natural world, how it is made, and how people are changing it. If you aren't formally educated in science or nature, basic college biology and geology textbooks are good starting points for obtaining a solid background, and a good world atlas is essential. Think of what interests you most, and follow your interests in books, magazines, and newspapers, as well as on the Web; these are valuable sources of story and assignment ideas.

Most editors and writers make it a practice to read the leading newspapers daily; many broadcast news stories and magazine articles follow immediately after events and research are reported there. *The New York Times* has a Web site of course, but you can get ahead of even it by visiting sites of the major news agencies or CNN, and scientific journals like *Science* and *Nature*. If you can't subscribe to a lot of publications or don't have the time to read them and/or surf the net daily, it is crucial for you to study as many environmental and nature magazines you can and find Web sites that digest environmental news. In them you'll find the ideas and photographs that are your competition and inspiration. As you begin to firm up a story idea or get deeper into a subject, respectfully try to contact leading scientists who might be willing to point to other research and who will know about upcoming field studies. The more omnivorous you are in your study, the better prepared you'll be when you decide to turn an idea into a self-assignment or when that editor's call actually comes.

Both physical and mental preparation are vitally important for any assignment. Nature photographers often develop the physical skills required for such outdoor activities as backpacking, mountaineering, skiing, kayaking, diving, and sailing, according to their specific interests. You must keep in shape and learn how to survive, not only in the natural wilderness, but also in urban locations.

Planning intensifies from the minute you mark a trip on your calendar. You must arrange for various practical concerns, including plane tickets, driving schedules, location routes, inoculations, passports, and many other personal and business details. Researching your subject becomes a priority, and you find yourself pulling out everything you have on file and on the bookshelves. (Over the years I've collected hundreds of maps, especially of North America, and I can quickly pinpoint locations and outline important destinations for long trips.)

Create a job envelope for each assignment, and start putting together relevant information. Call or e-mail embassies, tourist bureaus, ranger stations, librarians, other photographers, writers—anyone who might offer important current information and ideas about where you'll be working. Find out if immigration documents, work permits, and/or visas are required. It is a good idea to consult the Center for Disease Control and the State Department for lists of medical and political dangers around the world. Working with a travel agent skilled in independent travel and relying on this individual to weave a path through the arcane and maddening thicket of air routes and fares can save both money and worry. Thoroughly understand your destination; all you want to be surprised by are wonderful light and unique compositions, not unexpected legal problems.

Begin compiling a shot list of the prospective subjects, places, and events that you, your editor, or your client want to be sure are photographed. Picture books, Web sites, and travel brochures provide excellent ideas for location shots. Continue refining and prioritizing the list. Note those shots that you can shoot vertically for possible use as cover images. Keep a copy of the list, along with a list of important contact names, itineraries, and telephone numbers, readily available. Make some extra copies for your home contact or studio assistants in case you lose your copy on location.

When you leave on the trip, bring along just the information from the job envelope

you'll need on location, leaving the rest for later reference to write captions or other text. Upon your return, the job envelope can become the repository for various important papers and documents, including receipts and invoices, caption sheets, correspondence with editors, and tearsheets of sample photographs from assignments. You can then start putting updated information for your next trip in this same envelope.

Since Mount St. Helens erupted, I've trained in order to be able to go almost anywhere, interact well with scientists, and come back with great images of important research. The reach of my environmental message has spread, thanks to magazines with international readership, such as The New York Times Magazine, Natural History, Audubon, Discover, *and* Smithsonian. *But assignments can be daunting, as was this "gripping" saga for* Smithsonian, *in which the researcher slogged the Venezuelan llanos barefoot, feeling for anacondas to capture and study. Luckily I like both snakes and swamps!*

Equipment

For many beginning nature photographers, deciding what equipment to bring on a shoot isn't a problem: they don't have that much to choose from. But for others, the important concern is taking along exactly what is appropriate for the particular destination and assignment. With healthy competition among the major brands, you have more great cameras and lenses to choose from than ever before. Whatever you use, you should make up a master checklist detailing everything you'll need to travel.

The checklist shown opposite is an annotated tally of what I brought along on a recent assignment. In addition to using an equipment checklist, I also lay out those items needed over and above what I usually have in my camera backpack. To double-check I inspect the pack to make sure that I have to take everything in it and regularly examine each item of equipment to make sure it is in good working condition. I put fresh batteries in everything, especially when I'm going to a winter or tropical location, where the climate notoriously drains batteries. If I'm taking along extra camera bodies that I haven't used for a while, I test them with a lens and flash, then store them in plastic Zip-lock bags for safekeeping. I make an inventory of all film and extra batteries on hand.

You should always do this equipment check enough in advance to have any necessary repairs made, to order film and other accessories, and buy any new gear. Depending on the details, all of this can take quite a while. Think twice before buying a new piece of equipment just before the trip; you'll need time to practice with it. Keep in mind that you can rent almost everything, so consider what equipment you'll definitely use again after you return.

You should also think about more than just the usual photographic hardware. Consider whether the photographs you're planning to take or the location itself require such items as underwater-camera housings, dust covers, special clothing, ropes and climbing gear, or specific modes of transportation. When I'm satisfied that I've covered everything, I open all of my camera cases, my carry-on backpack, and my duffel bags and pack away.

The increase in the number of air travelers and terrorist bomb threats have made it more difficult for photographers to fly. Less carry-on luggage is allowed, and baggage is now frequently X-rayed with powerful beams that fog film. I try to fly with as little equipment, as few bags, and as little fanfare as possible.

If I'm checking my camera cases at the airport, I put them inside duffel bags or slightly larger suitcases to thwart thieves. Use plain luggage-identification tags; don't announce that you are "John/Jane Smith, Photographer." It is usually better to carry as much film as possible with you and check the hardware instead. Hand-checking film is made easier if you carry the film canisters "naked" in clear plastic bags. Put the cardboard boxes in the recycling bin, but pack the empty plastic canisters for safe storage of the film when you get to your location. I also make a point of keeping at least one camera and a few lenses in my carry-on bag in case my checked equipment does get lost. In all cases, contact the airline about its current carry-on policies, as well as any special requirements you might have.

Don't underestimate the problems of getting through customs. Carrying a proper passport and *carnets,* or registered letters of assignment, keeping a generally low profile, and moving as a tourist are all excellent strategies for trouble-free international travel. Sometimes too much film equipment or gear becomes a reason for airport and customs officials to "investigate" your passport; your equipment might then be impounded or held for state taxes. Getting out of all the red tape might require negotiation, cajoling, even diplomatic ploys. Be sure to bring your documents with you, and learn all you can beforehand.

Maintaining Discipline

I endure a lot of good-natured barbs from friends and family about my so-called "vacations," from which I return with quite a few wonderful pictures. Long, expensive business trips with specific photographic goals are seldom relaxing, however, and even though I enjoy travel, the life of a working photographer on the road is usually no vacation. This is especially true when you are on assignment because of the added pressure of having to produce great images on demand for the client. Saying, "Oh no, I missed that shot," is harmless when you're taking pictures for your own pleasure. Editors and clients, though, reserve a special hell for photographers who return with more excuses than images. This hell is called "No More Jobs." Theft, hotel fires, storms, strikes, car breakdowns, curious local police, illness, injury, bad water, no water, too much water—all of these gremlins can distract you and prevent you from doing the work you set out to do. But the work still needs to be done. Even on an uneventful trip, you must be prepared and fit, both physically and mentally,

for anything. Keep track of how stressed and tired you feel; panic and exhaustion don't result in good pictures. Take a day off if you need it, or at least spend a comfortable night in a good hotel, as an antidote to the long and sometimes frustrating details of travel.

It is also important for you to stay in touch with your home base—with your family, friends, and client—for the sake of your business as well as your own well-being. Acquire an international calling-card number and cell phone, keep track of the closest telephone or telex office, and leave word of your next destination wherever you stay. You can interface with your home office and clients via e-mail, even sending back photographs and promos. Fax machines, which are becoming increasingly available for public use, are an excellent way to communicate far from home. After a long day of hard work, it is comforting to call home from a foreign land, lonely and tired, to hear a loved one's wonderful voice with news and a reminder: "Honey, don't forget to shoot enough verticals!"

EQUIPMENT CHECKLIST

Main camera bag:

- Primary camera body (autofocus, etc.) and spare camera body
- Lenses: 20mm, 35mm, 50mm (F1.8), 105mm (macro), 80-200mm zoom, 300mm
- Filters (to fit all lens sizes): 81A, 81B, polarizer, neutral-density, split-field, 80B (converts incandescent light to daylight), neutral-density 0.9
- Medium flash unit, small diffuser, and off-camera extension cord
- Cable release and trigger on 25-foot-long cord
- Film: ISO 50, ISO 100, and the newest, sharpest fast or pushable emulsion
- Toolkit: flashlight, lens-cleaning paper and cleaner, extension tubes, lens reversing ring, spare batteries, lens caps, Swiss Army knife, needlenose pliers, pens and markers, waterproof notebook, compass, bubble level, anti-fog solution, spare tripod knob, 5 x 7-inch white reflector card, soft wire, gaffer tape, small screwdrivers, insect repellent, sunblock lotion, plastic bags, extra camera straps, film-leader retriever, watch
- Binoculars
- Fanny pack (often carried separately with a basic camera/lens system)
- Clean cotton handkerchiefs
- Rainwear, hat with brim, and light gloves
- First-aid kit and small amount of toilet paper
- Tripod and quick release mounts for cameras and lenses

Other items as needed:

- Backup camera bodies (including an old, semi-mechanical model like a Nikkormat)
- Waterproof snapshot camera and/or small digital camera
- 500mm or 600mm lens and 1.4X extender
- Extra film (estimate 10 rolls per full shooting day)
- Flash accessories: battery, spare flash unit, flash bracket, and extra sync cord
- Radio flash and camera remote
- Small extra tripod
- Waterproof river bags
- Silica-gel desiccant
- Extra batteries, plastic bags, lens paper, and insect repellent
- Headlamp, spare flashlight, and bulbs
- Waterproof boots or waders
- Ground cloth and/or camouflage cloth
- Cloth bag for on-tripod camera cover
- Expanded first-aid kit
- Emergency food (energy) bars
- Head net
- Work clothes
- Laptop or handheld personal scheduler
- GPS unit and radio tuned to local rescue and aircraft frequencies
- Personal accessories as needed

MARKETING STRATEGIES

There is a very special place in all photographers' hearts for the memory of their first published photograph. Mine appeared on the cover of *American Hiker*, a long-defunct magazine. I treasured the image even though it was a poorly reproduced black-and-white conversion of a color slide. As it turned out, however, quality publishers also seemed interested in printing my work. That is why I decided to go to New York City and try to dovetail my interest in the great outdoors, my training in journalism, and my desire for more publishing opportunities.

As you consider how to market your images and get them published, you should realize that independent, freelance photographers are an important resource to photo editors. Editors need pictures, and as many sources as possible to meet the continually shifting requirements of each issue or project. Editors (many of whom are freelancers themselves) and freelance photographers depend on each other. Although they might have hassles—over lost pictures, low pay rates, and/or difficulties due to inaccurate captioning and text—they share a strong mutual interest in publishing great pictures that serve both of them well.

Reaching Your Markets

Nature photography is perhaps the most popular genre of photographic art. Scenic vistas are probably the most widely published images, but pictures of nature patterns, details, and creatures are also seen everywhere. They are attractive to publishers, advertising agencies, and consumers because of the range of their subjects, from botanical illustrations, to strongly emotional icons, to soft, impressionistic graphics. Pay attention to the messages these pictures convey, and in which medium you find them. Easily recognized scenes that are pleasing and popular are ideal for sale to postcard and calendar publishers. National park scenes are the most obvious subjects. These wonderful images are always marketable, although they aren't necessarily easy to photograph.

The most pleasing nature images feature strong, classic composition and graphic use of color combinations. Curving, circular, and spiral patterns seem to be viewer favorites. More active nature images—mountains, crashing waves, storms, growling and running animals—aren't as common, but they are still familiar and popular. These images tend to incorporate more angular compositions and less restful colors; many of them contrast blacks and strong complementary colors and are shot in vertical formats. Other top-selling subjects in stock agencies include frogs, penguins, clouds, animals showing personality, water patterns, beach scenes, and, of course, the sun.

The best way to learn about marketing possibilities is the same as the best way to approach nature ideas and locations: read and study everything available. As you read and do market research, keep lists of the names of editors, publishers, and designers, as well as their mailing addresses and telephone numbers and the photographs they seem to favor. Become as avid a reader of mastheads and photo credits as you are of the articles themselves. Throw your net wider and explore advertising brochures, Web sites, newspaper supplements, company annual reports, postcards, fine-art posters—in fact, any and all prospects for your photographs. Start and continually update a clip file. Through photo-credit listings, business directories, Internet searches, and telephone calls, try to find out who selects and publishes the pictures.

Armed with your list of agencies, publications, and people who might want to review and use your work, develop a marketing plan to determine which are the most important to you or seem most likely to give you a sale. What do you have on file that will immediately interest them? At this juncture, it is wise to read books or attend seminars on

marketing and business practices, and portfolio selection and presentation.

How should you present your work? I've found several ways that work for me, primarily focusing on editorial contacts. I send color copies or tearsheets of my printed, published work. I usually arrange for extra copies with a magazine the minute I learn that it is going to publish a good picture of mine. Sometimes tearsheets are free, but usually I offer to pay costs or a portion of the cost for 200 or 300 copies. If you wait until publication, it is much more expensive to get copies. Tearsheets are valuable because they are proof of your professionalism, and they show that another editor had confidence in your work. I also mail out crisp, direct color copies of magazine spreads, reduced onto 8½ x 11-inch paper. If you have Adobe Photoshop, PageMaker, and a good color printer, you can design your own beautiful mailings reproducing printed work. Choose a database program that will help you manage the mailing list and produce attractive-looking labels and envelopes.

The Internet provides other possibilities: your own Web site or a portfolio on a photographer's service like AG Editions. Your own Web site gives you a chance to work with a Web designer and server to create a beautiful presentation, offers many more images, and enables people—potential clients—to contact you directly via e-mail. The difficulty, similar to that associated with doing your own mass mailing, is getting the right editors to see your work. The best initial plan is probably to alert your list of potential clients to your site by "snail mail" and then follow up by telephone or e-mail. You should also pursue links from any sites you have contacts with, such as environmental groups, galleries, local ASMP or photography groups, and magazines. Remember to protect your copyright by registering your images, printing an adjacent copyright credit, keeping images "low resolution," and using a watermark or anti-theft program like Digimark. With most photo researchers doing some searches on the Internet, it is more and more important to have a presence there.

Another way I promote my work is by assembling a selection of 20 to 40 well-made

This February, 1977, cover of Popular Photography *marked my first big, national-magazine exposure, an eight-page article entitled "For Love of Wilderness" with nine photographs.*

Italy's Zoom *magazine, known primarily as a fashion-photography showcase, featured work by Maine Photographic Workshops instructors one summer, and included my nature portfolio. I extended the good publicity by purchasing bound reprints from the magazine, which I've mailed to hundreds of editors and art directors.*

duplicate slides of my best images (or a page of crisp thumbnails downloaded from a Photo CD) corresponding to outlines of specific story ideas. This lets editors know that I am serious and willing to work, and is particularly effective after an initial contact. They want to see a directed, positive attitude in addition to talent. Established pathways for breaking into design and advertising work include having your own brochure or a series of mailing cards designed and custom-printed. After all, you're advertising to advertisers! Also, having your work published in design magazines, such as *Communication Arts,* will get you noticed in that world.

When editors or designers initially request to see more of your work or accept an appointment, be courteous and conscious of their busy schedules—many other photographers are clamoring for their attention as well. Show your work and state your ideas clearly; don't overwhelm the editors and designers with too much material or with examples of work that for any reason is not equal to or better than what the clients publish. Remember, less is definitely more in a good presentation.

The Value of Photographs

A potential client, in a request for photographs for a specific use, begins a relationship with you that is a two-way communication and negotiation of work and ideas. The client has come to you for visual content and, often, for advice; you, in effect, loan out your original photographs for the purpose of being published, paid for, and returned safely. When clients call for photographs, you must understand clearly who they are and what publication they represent; what images they seek; and how they intend to use them and ultimately pay for their use. On your part, you must make clients feel confident that you have or will produce the pictures they need, that the images will arrive on time, and that you'll abide by any exclusive use provisions agreed to.

Just as in most of your other business dealings, the transfer of valuable work requires a basic contract or delivery memo that is mutually agreeable to both parties, lists the specific images and uses, and holds each party to specific business practices. During the marketing of millions of pictures for many uses, standards have evolved for the commercial use of photography. These practices commonly include: one-time-only use; return of all submitted pictures as soon as possible; a credit line for the photographer on any publication; protection by copyright of each picture or the entire publication; payment within a specified time from date of invoice (usually within 30 days); and an understanding that the client will fairly compensate the photographer for the loss of any images. Unfortunately, sometimes many opinions exist on these and other points, and in this electronic, business-oriented age, disagreements are getting bigger. One common split comes when publishers, seeking more content at less cost, want to reuse images on Web sites or subsidiary publications without paying more for the right to do so. Some of the usual outlets for photographers just getting started, such as specialty magazines and local publications, want to pay less and less for any use, despite the rising costs of making the images.

Photographs prepared for any kind of publication today exist as electronic data, and are easily stored, easily transmitted, and easily duplicated. It is an especially dangerous and confusing time for those just beginning to offer their pictures to publishers. But anyone who wants to publish photographs needs to be aware of the dangers. And active amateurs with the occasional sale should stand shoulder to shoulder with experienced professionals.

Photographs have value. Beyond the personal values attached to pictures, and beyond their intangible values in aesthetics, education, etc., photographs are worth something to those who publish them. Their need for pictures usually is not optional. Guidebooks, consumer magazines, nature books, and advertising brochures just *have* to have them. While the need for photographs probably is not a choice, the need

for individual particular images usually is. Publishers can pick and choose from among the many photographers out there.

But this doesn't mean that the prices for photographs should be driven down to the vanishing point in a cutthroat competition among photographers. Perhaps some think they can survive on credit lines alone, but the world of nature photography can't. Keep in mind that competition and downward price pressure exist in every field, but businesses can survive only by getting fair prices for their product. Almost all professional nature photographers, famous or not, actually get by on small, frequent, low-fee uses and reuses in books, magazines, and simple brochures. The national average fee for a stock photograph is about $400, and for nature pictures in editorial use this figure is probably below $200. Recognize the value of your pictures, and don't contribute to dropping the average price. Guard your copyrights, and register them. They are yours at the moment you create a photograph, but every public use must carry the copyright notice. Beware of contracts that take control of re-publication and other use rights, beyond the immediate use, without fair additional compensation. They are your images, and *you* should dictate their use and value.

You need to know much more about conducting a photographic business than I can detail here. Such concerns as pricing your work, dealing with stock agencies, and negotiating book contracts take a great deal of experience and even legal advice. My counsel is, first and foremost, don't be afraid to ask another photographer.

More and more photographers are keeping in touch on business matters through e-mail networks and Internet forums. If you are marketing your photographs, you should join ASMP. No organization is better at finding out how to run a business and keep up on trends and dangers in marketing. In *The ASMP Business Bible,* Chapter 9 covers the business of stock photography, and Chapter 10 recognizes nature and travel photography as specialties. NANPA, although not as business-oriented as ASMP, is focused on nature photography and provides information and

seminars on marketing. Up-to-date information and warnings about rights, contracts, and copyrights is available from the American Society of Journalists and Artists, whose Web site has "Contract Watch" and "Contract Tips for Freelancers." A number of commercial pricing guides and newsletters exist, some of which are listed in the Bibliography (see page 143).

In 1993, the editors of Life *magazine called me in; showed me one of those paintings of the rainforest in which every insect, flower, and animal is visible; and said, "We'd like to do something like this." Such illustrations are fantasy, and impossible to photograph, but I could try to show the life in a single tropical tree, symbolic of biodiversity. I hired guides and a tree climber, and for three weeks I photographed everything I could around and in a buttressed 200-foot-tall tree in Costa Rica. For 17 days and seven nights, I worked from a tiny platform 150 feet up. I used everything from a 6x1 / panoramic camera to a 500mm lens with a tele-extender, and shot 125 rolls of Fuji Velvia. The result was this 10-page article in* Life, *a mini-encyclopedia celebrating tropical diversity—and the start of a series of assignments.*

COVER:
PHOTOGRAPH BY KEN EWARD
INSET: MAO-WING TÖNGREN PHOTO

LIFE
Departments
APRIL 1998

From 1993 through 1998, I photographed two more biodiversity assignments for Life, *working with a staff researcher and writer. I spent two weeks around an alligator hole in Everglades National Park and then focused on a small tidepool on the Monterey, California, coast. Working with scientists to ensure accuracy, my team came up with a picture of a crucial, endangered ecosystem. These stories have strong, ethical guidelines that limit me to photographing only animals and events that occur right at my small subject area within a certain time. The challenge for me is to become an observant resident in the place, ready to photograph anything I see, on its level. This has pushed my artistic, naturalist, and technical skills beyond previous limits. On this tidepool assignment, I photographed under salt water for the first time, including closeups of incredible nudibranchs; felt the power of surf crashing into the seaweed; and witnessed the birth of oystercatcher chicks.*

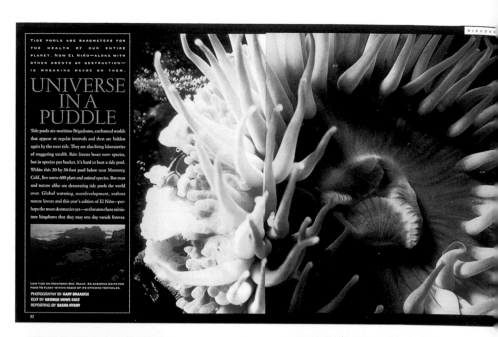

TIDE POOLS ARE BAROMETERS FOR THE HEALTH OF OUR ENTIRE PLANET. NOW EL NIÑO—ALONG WITH OTHER AGENTS OF DESTRUCTION—IS WREAKING HAVOC ON THEM.

UNIVERSE IN A PUDDLE

Tide pools are maritime Brigadoons, enchanted worlds that appear at regular intervals and then are hidden again by the next tide. They are also living laboratories of staggering wealth. Rain forests boast *more* species, but in species per bucket, it's hard to beat a tide pool. Within this 20-by-30-foot pool below near Monterey, Calif., live some 600 plant and animal species. But man and nature alike are desecrating tide pools the world over. Global warming, overdevelopment, zealous nature lovers and this year's edition of El Niño—perhaps the most destructive yet—so threaten these miniature kingdoms that they may one day vanish forever.

LOW TIDE ON MONTEREY BAY, RIGHT: AN ANEMONE WAITS FOR FOOD TO FLOAT WITHIN REACH OF ITS STINGING TENTACLES.
PHOTOGRAPHY BY GARY BRAASCH
TEXT BY GEORGE HOWE COLT
REPORTING BY SASHA NYARY

52

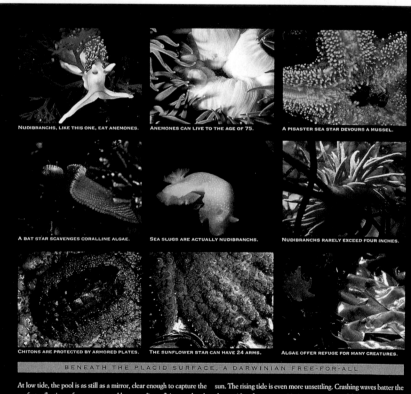

NUDIBRANCHS, LIKE THIS ONE, EAT ANEMONES.

ANEMONES CAN LIVE TO THE AGE OF 75.

A PISASTER SEA STAR DEVOURS A MUSSEL.

A BAT STAR SCAVENGES CORALLINE ALGAE.

SEA SLUGS ARE ACTUALLY NUDIBRANCHS.

NUDIBRANCHS RARELY EXCEED FOUR INCHES.

CHITONS ARE PROTECTED BY ARMORED PLATES.

THE SUNFLOWER STAR CAN HAVE 24 ARMS.

ALGAE OFFER REFUGE FOR MANY CREATURES.

BENEATH THE PLACID SURFACE, A DARWINIAN FREE-FOR-ALL

At low tide, the pool is as still as a mirror, clear enough to capture the perfect reflections of cormorants and brown pelicans flying overhead. Below the surface, however, thousands of organisms compete for every last centimeter of real estate. A volcano-shaped limpet rams another limpet that dares nibble at its turf. An orange bat star wraps itself around a mussel, an embrace that turns deadly when its hundreds of suction-cupped feet—one biologist likens them to tiny toilet plungers—busily pry open the shell. Everywhere, life is piled on life: A barnacle finds space atop a limpet that has plastered itself to the algae that have grown on a hermit crab that has annexed a turban shell.

The receding tide triggers a game of maritime musical chairs in which organisms scramble for damp, shady spots, fleeing the killing sun. The rising tide is even more unsettling. Crashing waves batter the shore with a force up to 30 times more powerful than the pressure under the foot of a standing human. Only the hardiest organisms can endure the chaos. Crabs wedge themselves into cracks. Mussels anchor themselves to rocks, like sailors lashed to the mast during a storm, by strong ropelike fibers. The surf is punishing but life-giving. The new water, cold and rich with oxygen, imports a fresh supply of food, a fecund broth of plankton, nutrients and detritus. "The wave action energizes the system," says John Pearse, a local marine biologist. "It sweeps out debris and turns things over. There's new space all the time." Which is fortunate, because each wave also brings in a host of new creatures looking for a place to call home. ➡➡

54

Presenting Your Work

A new approach to image distribution and promotion has been developing for a few years. Standard practice in the publication industry has been to look at and use slides rather than prints. Even though more and more editors are finding and viewing images online or as Photo CDs, most request an original or high-resolution transparency output for the final selection. Clearly, as the scanning and transmission of photographs become more and more high quality—and less expensive—this is going to change until most publications will be able to accept an online delivery of scan data at the resolution they require. The days of shipping valuable original chromes all the time will be over. Several of the giant stock-photography agencies have tens of thousands of images scanned and available at their Web sites. Other agencies offer Photo CDs with a selection of images and can send out custom portfolios upon request. Scanning the thousands of photographs you might send out in a year and maintaining the storage and online capability to display and deliver them are still expensive propositions. But individual photographers can benefit from some of this technology immediately by having their portfolios and story-package sets burned onto a Photo CD, from which printed and e-mail samples can be made. You can put portfolios for specific clients to view on your Web site, even providing them with a password for repeat access. You can set up e-mail networks of editors—with their permission, of course—to keep them informed of news and samples of your work.

Since photographers conduct so much business over telephone lines or by courier, it is a great idea to visit your most important clients and prospective editors from time to time. Many photographers, including me, prefer to project slides in person during these appointments, but this is becoming less and less possible and practical. On your first promotion trip you might not get even that far. Editors frequently welcome portfolios from photographers they know casually only if the cases are dropped off on a particular day at their offices. Ask how they prefer work to be submitted.

The alternatives to projection, which you should be ready to accommodate without delay or complaint, include presenting your work in clean, black-cardboard mounts for viewing on light tables, showing professionally displayed tearsheets of previously published work, or supplying prints in a portfolio box. Include original slides only if you're going to be in charge of them every minute you are with the client. Too many photographs have been lost or damaged in the portfolio-review process, so don't risk your originals. Spend what you must to have good "dupes" made for portfolio presentation, but make it clear to the editors that they are duplicate slides. Many editors are aware of the risk of loss and prefer dupes in portfolios anyway.

When presenting your work, show knowledge of what the client uses, likes, and has recently published. Leave behind a well-printed sheet of information about your work and your pictures, including publication credits. Follow up all contacts with appropriate further submissions or the specific information a client requests.

Cultivate and be appreciative of individuals who show particular interest in you and your work. If you don't get a response after a portfolio submission, use the occasion of an upcoming trip or another good piece of published work to write to the client again, and make a follow-up call. Over a period of time, a consistent look and style should develop in your presentation, mailings, and interviews. You might have many story ideas to bring to editors. As the best salespeople will tell you, the key to selling yourself well lies in continuing the contact; most sales are made only after many pitches.

Eventually, you might find it advantageous to expand your direct client base by advertising in trade publications or photography directories, such as *The Creative Black Book* or *Direct Stock* or their Internet manifestations. But make sure that the publications you choose present your work to an appro-

priate client base. Some ad books don't seem to do much for nature photographers who are not heavily into advertising or corporate work. The same limitation applies to the idea of having your work represented by a photo rep in a major city. Because nature photography offers few lucrative assignments and because most nature photographers don't do high-paying advertising or corporate work, professional reps don't usually find it financially rewarding to promote them.

Most nature photographers go it alone, and believe that personal contact with editors is what gets them the most jobs and stock requests. Keep in mind that, naturally, many more editors see the images of widely published photographers than they do less frequently published photographers. You can increase your visibility while serving your industry through work for associations or as a workshop instructor. Send out press releases to local media, association newsletters, industry magazines, and Web sites whenever you score a big article or win an award. As your reputation grows and your photographs are more widely seen, you'll find that new clients and publications become interested in publishing stories about you and your work, all of which increases the best marketing strategy: word of mouth.

Marketing Stock Photography

A file of existing or stock photographs is the bread and butter of most money-making nature photographers. Almost all images published come from someone's library of pictures. Although more photographs are being used than ever before, it is also perhaps more difficult than ever for a beginner to break into this crowded market. Some photographers shoot specifically for stock, setting up trips to frequently-asked-for places, such as national parks. Almost everyone carefully watches what is being printed and what editors ask for, and tries to aim the camera in that direction when they can. It is a good idea to subscribe to several stock-photo-request clearinghouses and marketing letters, like *The Guilfoyle Report* and its associated online services.

When editors begin to call or you see a specific request for images, you need to respond quickly with appropriate work. Devise a stock-photo filing system that works for you, one in which you can place each photo and always refer to after you caption it. The standard filing systems consist of transparent, pocketed sheets stored in notebooks or hanging file drawers, commercial files with 2 x 2-inch (or larger) drawers for storing individual transparencies, and the ever-popular plastic slide boxes that come back from the lab. I file my best selections of often-reviewed subjects in slide sheets, with the majority of my pictures in carefully labeled file drawers.

Find a system that works for you to label slides with captions and discrete numbers, organize and track ongoing editing projects, follow up shipments that you've made, and—the happy end result—send invoices to the publishers. Active stock photographers use computers with a tracking system they devise or with a commercial program that is advertised in most photography magazines, as are books on the subject. Many photographers also have learned that success doesn't come to those who are not home to send out their photographs, so they've hired stock assistants. When you send out transparencies for review, neatly and completely caption them, mark them with your copyright, and place them in individual sleeves to help prevent scratching. The illumination from lightboxes and slide projectors fade transparencies over a period of time, so keep this illumination to a minimum.

The organization of the file itself is a matter of personal taste. In general, filing by subject matter can cover individual subject titles, such as "Peonies" or "Mushrooms." Filing by geographical location can organize the work from whole shoots or locations from which you have many images, such as

Photographing a wide variety of subjects can be the basis of a lifelong, lucrative career in stock photography. Clean design and clear illustration of natural phenomena are the hallmarks of these images, some of which are my most consistent sellers.

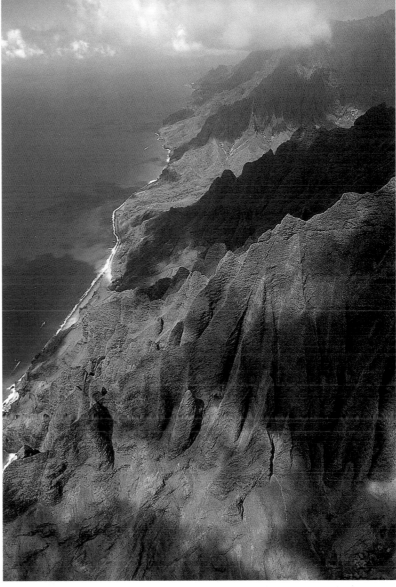

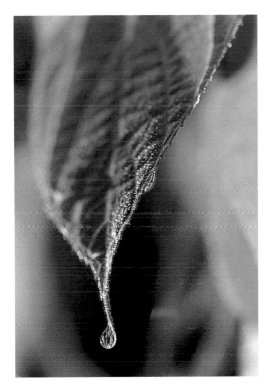

"Montana" or "European Trees." I also cross-reference between geographically arranged files and those filed by specific subject categories. Many photographs can conceivably be used to illustrate a specific place or activity and might also contain symbolic meaning. Finding the right image in your stock file to fill a request is a combination of organization and labeling, a visual memory of your images, and imagination. Remember that slides that aren't completely captioned and correctly filed might as well be lost.

Photographers also market their images through stock-photography agencies, which typically have many more clients and do more advertising, and take 30 to 60 percent of each fee for licensing the photographs. The corporate online age has ushered in a restructuring of the stock-photography business and has witnessed the emergence of several enormous international agencies. These corporations also deal in historic images, news photographs, setup advertising shots, movie clips and video, with millions of pictures on file. The companies are also heavily into electronic marketing. Along with these agencies are hundreds of smaller shops that are also aggressive marketers but which specialize more, including in nature.

Dealing with agencies can be frustrating for several reasons. They are in a buyer's market for images, they often have complicated contracts with exclusivity requirements, and you might be just one of hundreds of photographers that they handle. However, an image chosen for an active agency catalog or online can realize great profits for the photographer. Also, many companies deal in "royalty-free" Photo CDs, for which photographers share royalty on sales of the disc but have to give up their copyright to the photographs and get nothing further for each individual use of their images. In the future, it appears that more smaller agencies will consolidate or be bought out; that most photo buyers will be doing at least some online research; that the percentage of fees larger agencies offer to photographers will get smaller; and that a glut of cheap photographs will drive down licensing prices for common uses. As always photographers with strong, innovative images will find markets, but it will not be easy. Before you decide to join an agency, get advice from other photographers, the professional associations, and perhaps a lawyer. Above all protect your copyrights because they constitute your options for the future.

My photographic odyssey has enabled me to see interconnections among ecosystems and the threat from changes in the global climate. Here, the National Science Foundation research ship Nathaniel Palmer works along the Danco Coast in Antarctica, where I've started photographing scientific research into the icy continent's complex links to the world climate and biodiversity.